How to be a Cartoonist...

WRITTEN & ILLUSTRATED BY PETER MADDOCKS

A FIRESIDE BOOK
PUBLISHED BY SIMON AND SCHUSTER
NEW YORK

A FIRESIDE BOOK
PUBLISHED BY SIMON & SCHUSTER, INC.

SIMON & SCHUSTER BUILDING
ROCKEFELLER CENTER
1230 AVENUE OF THE AMERICAS
NEW YORK, NEW YORK 10020

PUBLISHED BY ARRANGEMENT WITH
ELM TREE BOOKS/HAMISH HAMILTON LTD.

FIRESIDE AND COLOPHON ARE REGISTERED
TRADEMARKS OF SIMON & SCHUSTER, INC.

MANUFACTURED IN THE UNITED STATES
OF AMERICA

ORIGINALLY PUBLISHED IN GREAT BRITAIN
UNDER THE TITLE: SO YOU WANT TO BE
A CARTOONIST?

10 9 8 7 6 5 4 3 2 Pbk.

LIBRARY OF CONGRESS CATALOGING
IN PUBLICATION DATA

MADDOCKS, PETER.
HOW TO BE A CARTOONIST.

ORIGINALLY PUBLISHED AS: SO YOU WANT
TO BE A CARTOONIST?
"A FIRESIDE BOOK."
1. CARTOONING TECHNIQUE. 1. TITLE.
NC1320. M264 1982 741.5 82-5761 AACR2

ISBN 0-671 45663-6 Pbk.

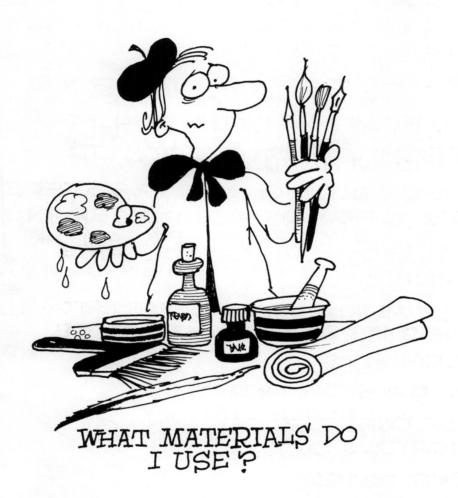

WHAT MATERIALS DO
I USE?

THE FIRST THING YOU WILL NEED IS PEN & PAPER...
SO LET'S LOOK AT WHAT WE HAVE —

I'M USING A RAPIDOGRAPH PEN FOR
THIS LETTERING
WITH A № 6 POINT

I ALSO LIKE
TO DRAW WITH
THIS PEN

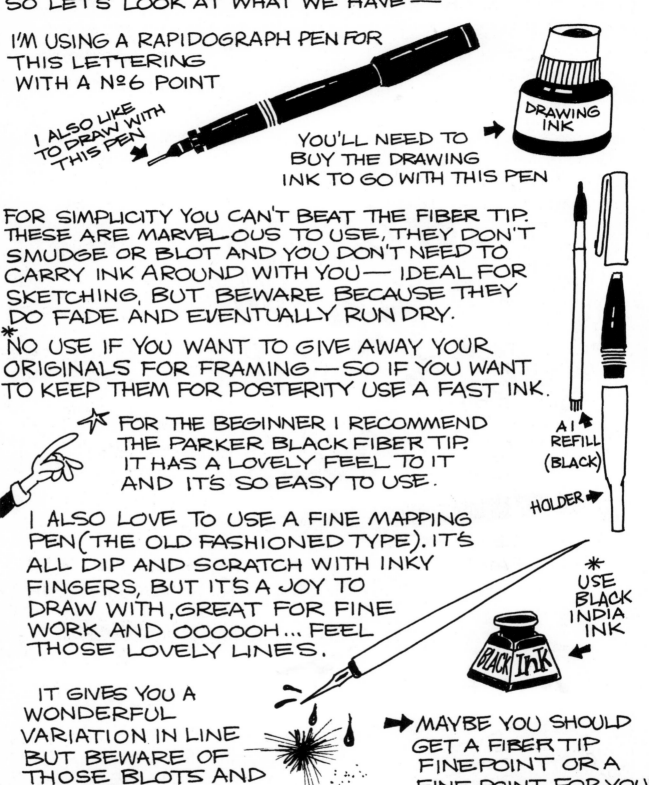

DRAWING INK

YOU'LL NEED TO
BUY THE DRAWING
INK TO GO WITH THIS PEN

FOR SIMPLICITY YOU CAN'T BEAT THE FIBER TIP.
THESE ARE MARVELOUS TO USE, THEY DON'T
SMUDGE OR BLOT AND YOU DON'T NEED TO
CARRY INK AROUND WITH YOU — IDEAL FOR
SKETCHING, BUT BEWARE BECAUSE THEY
DO FADE AND EVENTUALLY RUN DRY.
* NO USE IF YOU WANT TO GIVE AWAY YOUR
ORIGINALS FOR FRAMING — SO IF YOU WANT
TO KEEP THEM FOR POSTERITY USE A FAST INK.

FOR THE BEGINNER I RECOMMEND
THE PARKER BLACK FIBER TIP.
IT HAS A LOVELY FEEL TO IT
AND IT'S SO EASY TO USE.

A1
REFILL
(BLACK)

HOLDER

I ALSO LOVE TO USE A FINE MAPPING
PEN (THE OLD FASHIONED TYPE). IT'S
ALL DIP AND SCRATCH WITH INKY
FINGERS, BUT IT'S A JOY TO
DRAW WITH, GREAT FOR FINE
WORK AND OOOOOH... FEEL
THOSE LOVELY LINES.

* USE
BLACK
INDIA
INK

BLACK INK

IT GIVES YOU A
WONDERFUL
VARIATION IN LINE
BUT BEWARE OF
THOSE BLOTS AND
SMUDGES
— OOPS!

MAYBE YOU SHOULD
GET A FIBER TIP
FINE POINT OR A
FINE POINT FOR YOUR
RAPIDOGRAPH PEN?

4

ONCE YOU'VE DECIDED ON YOUR PEN———
(AND YOU WILL CHANGE YOUR MIND OVER AND OVER AGAIN)
YOU WILL NEED A BRUSH FOR THE SOLID BLACKS.

A NUMBER **2**
AND **4** SABLE
BRUSHES WILL
BE ALL YOU NEED

OH— GET ANOTHER EXTRA №4 FOR YOUR PRO
WHITE — THIS IS FOR CORRECTIONS AND YOU WILL
ALWAYS WANT A CLEAN BRUSH...

GET YOURSELF
A JAR FROM YOUR
LOCAL ART SHOP
— YOU'LL NEED IT!

WHILE WE'RE
ON THE SUBJECT
OF BLOOPERS &
CORRECTIONS—

ONE OF THOSE
NON-STICKY
STICKY STUFF
STICKS IS
ALWAYS
USEFUL

GET YOURSELF SOME

SHARP SCISSORS
FOR PATCHING...

MORE OF THIS LATER

A HARD LEAD PENCIL
FOR DRAWING LINES (FORGET THOSE ROUGHS)
LEARN TO DRAW DIRECTLY WITH A PEN

PLUS

A BLUE PENCIL FOR INDICATING TINT
* MORE LATER

WATCH YOUR FINGERS,
YOU'RE GOING TO NEED
THEM, IF ONLY TO TURN
THE PAGES OF THIS
BOOK

A SHARP KNIFE FOR TRIMMING
THINGS, SHARPENING THINGS
AND NEVER BEING ABLE
TO FIND THINGS
WHEN YOU NEED THEM

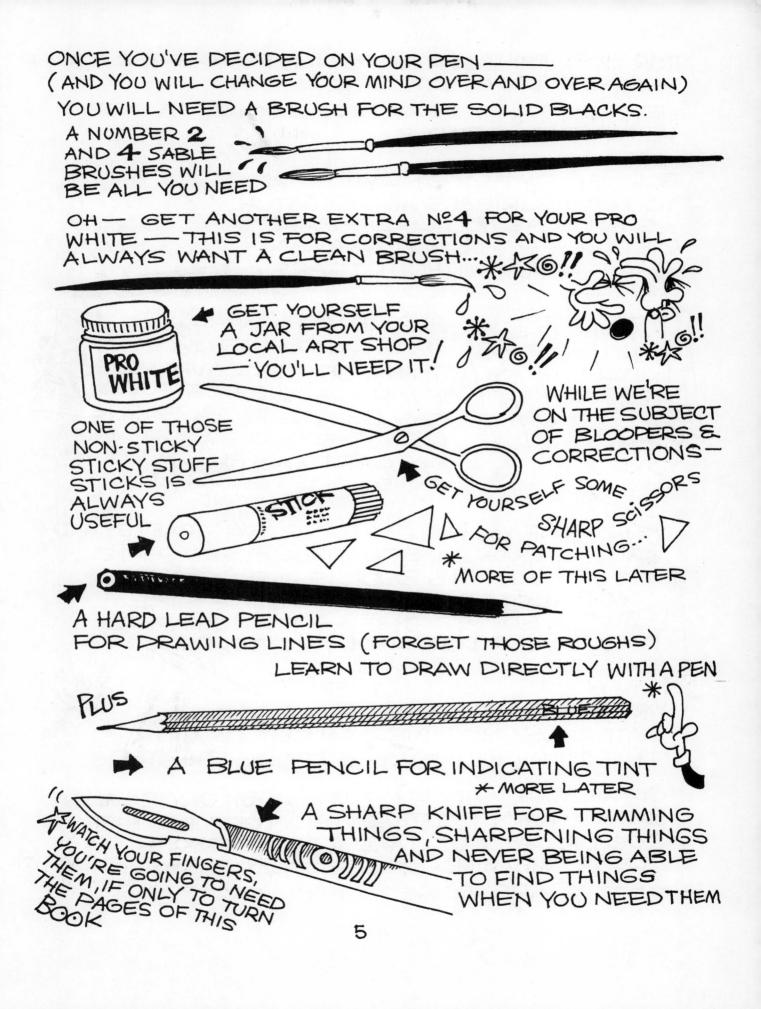

FOR DRAWING PAPER OR POSTER BOARD GO NO FURTHER
THAN YOUR LOCAL STATIONER'S —
GET YOURSELF A REAM (500 SHEETS) OF
WHITE TYPING PAPER.

FORGET THAT EXPENSIVE BOARD.
YOU CAN SCRIBBLE AND SCRATCH
AS MUCH AS YOU LIKE — MAKE
MISTAKES — THROW IT AWAY AND
START AGAIN WITHOUT TEARS

ALSO IF YOU WANT TO TRY
TO SELL YOUR EFFORTS —
THINK OF THE SAVINGS
ON MAILING, AND POSTAGE
CAN BE A VERY EXPENSIVE
ITEM THESE DAYS, MAILING
SIX CARTOONS PLUS A RETURN
ENVELOPE REGULARLY...

IF YOU WANT TO BE ARTSY—CRAFTSY AND
DRAW ON BEAUTIFUL BOARD — FINE.
BUT THIS BOOK IS ALSO GOING TO
CONTROL YOUR DRAWING SIZE —
— SO GET THAT ➤ TYPING PAPER
AND DO AS YOU ARE TOLD... IT'S MY BOOK

WELL — THAT'S ABOUT IT. YOU'VE GOT YOUR
MATERIALS, NOW WE CAN GET ON WITH
THE DIFFICULT PART—GETTING STARTED

CLEAR YOUR KITCHEN TABLE, DESK OR DRAWING
BOARD, TURN THE TELEVISION OFF, PUT THE
DOG OR CAT OUT. TAKE A DEEP BREATH,
CLEAR THE MIND OF EVERYDAY RUBBISH
—— WE ARE GOING TO THINK CARTOONS...

WHAT SIZE DO I DRAW?

SIZE — WHAT SIZE TO DRAW?
I'VE KNOWN CARTOON EDITORS WHO SELECT CARTOONS ON
SIZE ALONE, REGARDLESS OF MERIT, ARTWORK OR
HUMOR ... SO GET USED TO DRAWING TO A STANDARD
SIZE.

TO HELP YOU DO THIS, TRY
DRAWING WITHIN THE TWO FRAMES
BELOW — ONE IS AN UPRIGHT
SINGLE COLUMN AND THE OTHER
A LANDSCAPE TWO COLUMN (APPROX)
(SAME FRAME USED UPRIGHT AND LANDSCAPE)

* GET YOURSELF A
PIECE OF STIFF
BOARD AND MAKE
YOURSELF A
FRAME SHEET.

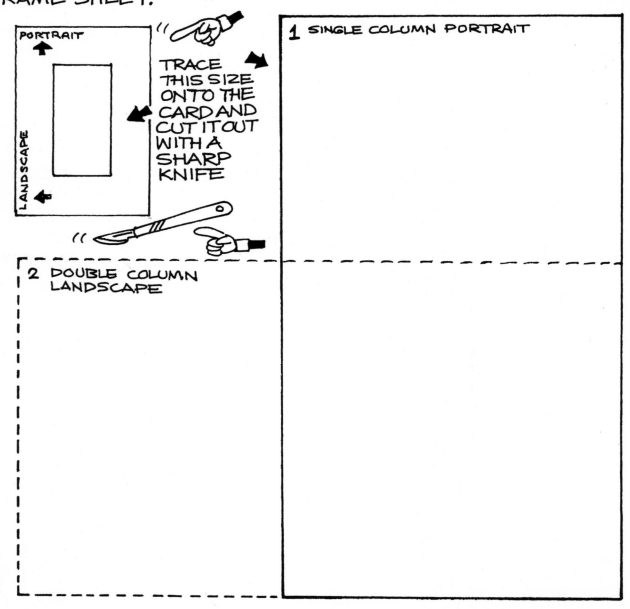

PORTRAIT

LANDSCAPE

TRACE
THIS SIZE
ONTO THE
CARD AND
CUT IT OUT
WITH A
SHARP
KNIFE

1 SINGLE COLUMN PORTRAIT

2 DOUBLE COLUMN
LANDSCAPE

NOW TAKE YOUR *FRAME SHEET PLUS THAT BLUE PENCIL I TOLD YOU TO BUY—PLACE YOUR FRAME SHEET ON YOUR PAPER OR PAD AND DRAW A FRAME WITH THE BLUE PENCIL (IT WON'T PHOTOGRAPH).

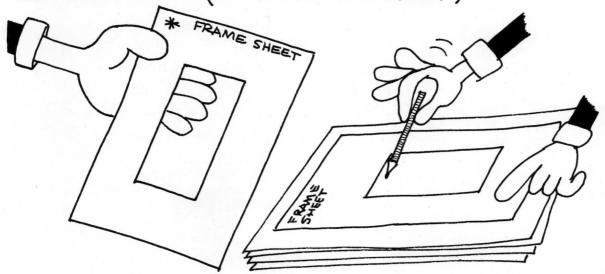

THIS WILL NOW GIVE YOU THE SHAPE AND SIZE MAINLY USED IN YOUR NEWSPAPER'S GAG COLUMNS. (WHEN REDUCED)——SORRY, ANY SIX – COLUMN MASTERPIECES WILL HAVE TO WAIT UNTIL YOU ARE A MASTER CARTOONIST——OKAY!

(THEY USE A BRUSH TO DRAW WITH ANYWAY)

I WANT YOU TO GET USED TO DRAWING DIRECTLY WITH A PEN——FORGET SCRIBBLING WITH A PENCIL, THEN TRACING EVERY LINE WITH YOUR PEN——IT'S SO STIFF—LOOSEN UP... DRAW FREELY WITH YOUR PEN. IT'S NOT EASY, BUT IT WILL PAY DIVIDENDS IN THE END ——BESIDES THAT TYPING PAPER IS CHEAP AND PLENTIFUL ENOUGH——SO GO AHEAD.

WHERE DO I BEGIN?

NOW FOR THE DIFFICULT PART—
WHERE DO I START?

 WELL, SOME PEOPLE
START WITH AN EGG...

OTHERS DRAW
A CIRCLE

NOT ME — I START WITH THE NOSE... A VERY
BIG NOSE
—IT'S MY
STYLE

THEN I ADD THE EYES...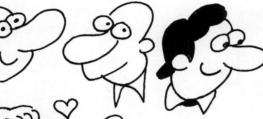

FOLLOWED BY THE FACE

TRY
IT

GO ON—
HAVE FUN
WITH IT...

JUST
FOLLOW
MY NOSE

IT'S MY STYLE OF
DRAWING PEOPLE—

WORRY ABOUT DEVELOPING
YOU OWN STYLE LATER...

MEANWHILE
WHY NOT COPY
MINE—IT'S
EASY.

BLACK IN THE HAIR WITH YOUR BRUSH...

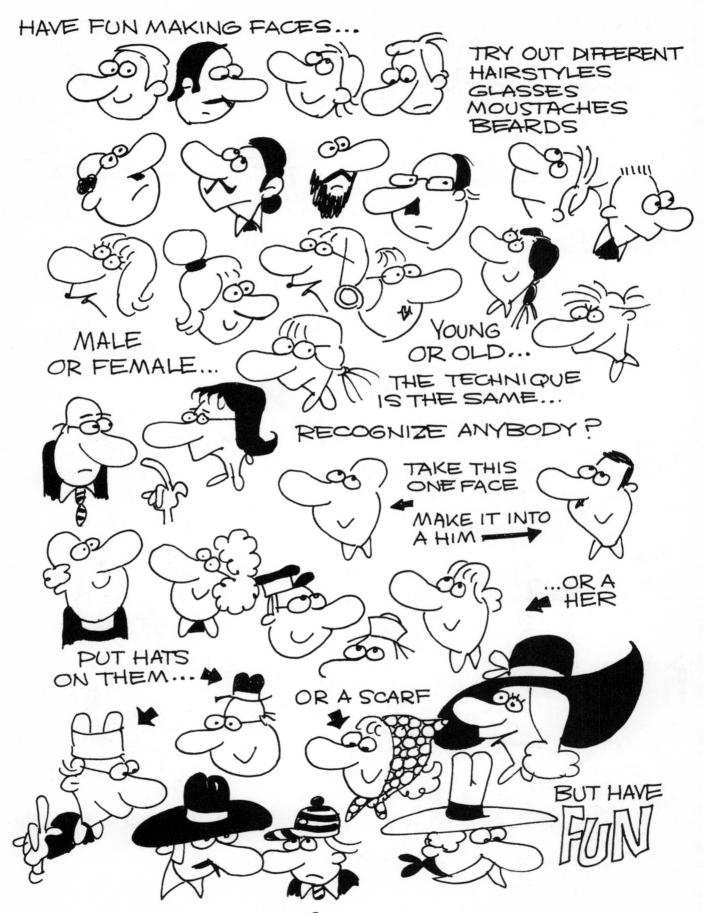

HAVE FUN MAKING FACES...

TRY OUT DIFFERENT
HAIRSTYLES
GLASSES
MOUSTACHES
BEARDS

MALE
OR FEMALE...

YOUNG
OR OLD...

THE TECHNIQUE
IS THE SAME...

RECOGNIZE ANYBODY?

TAKE THIS
ONE FACE

MAKE IT INTO
A HIM ➡️

...OR A
HER

PUT HATS
ON THEM... ➡️

OR A SCARF

BUT HAVE
FUN

YOU CAN'T DRAW ENOUGH FACES BECAUSE FACES HAVE EXPRESSIONS... AND EXPRESSIONS TELL A STORY

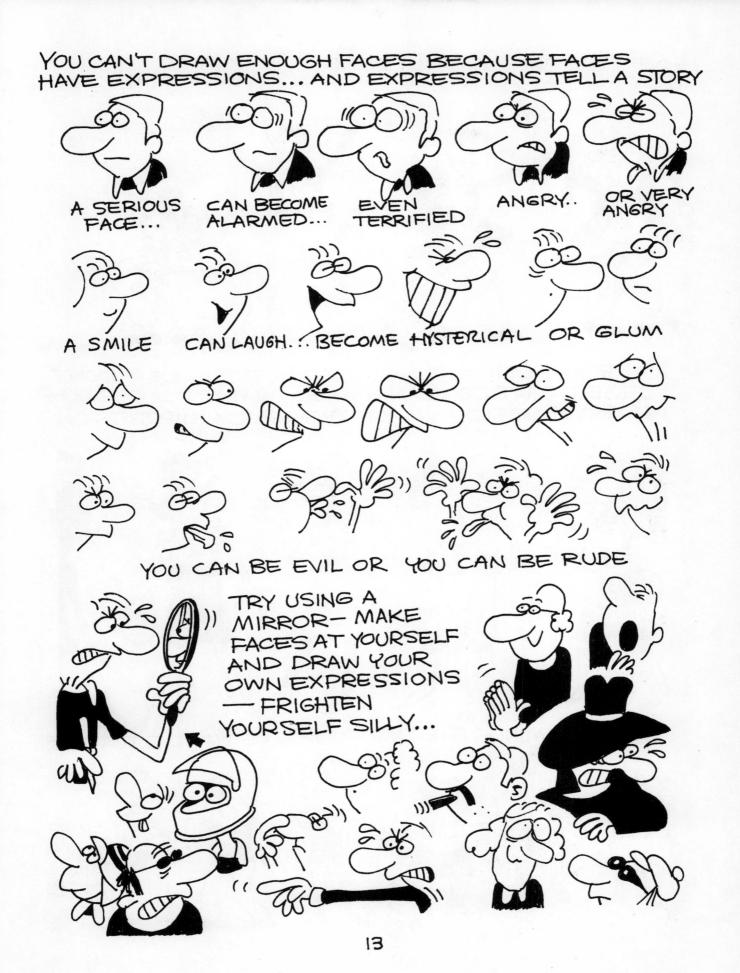

A SERIOUS FACE... CAN BECOME ALARMED... EVEN TERRIFIED ANGRY.. OR VERY ANGRY

A SMILE CAN LAUGH... BECOME HYSTERICAL OR GLUM

YOU CAN BE EVIL OR YOU CAN BE RUDE

TRY USING A MIRROR— MAKE FACES AT YOURSELF AND DRAW YOUR OWN EXPRESSIONS — FRIGHTEN YOURSELF SILLY...

EXPRESSIONS ARE NOT ONLY FUN TO DRAW—
THEY PLAY A MAJOR ROLE IN MAKING A GAG WORK.

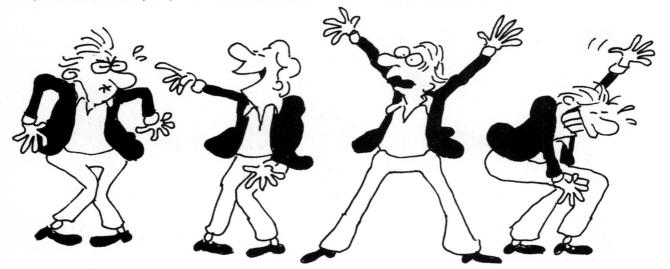

AN EXPRESSION IS NOT JUST IN THE FACE — DON'T
FORGET THE BODY LANGUAGE... WATCH PEOPLE DEEP
IN CONVERSATION, WATCH THEIR BODY EXPRESSIONS.

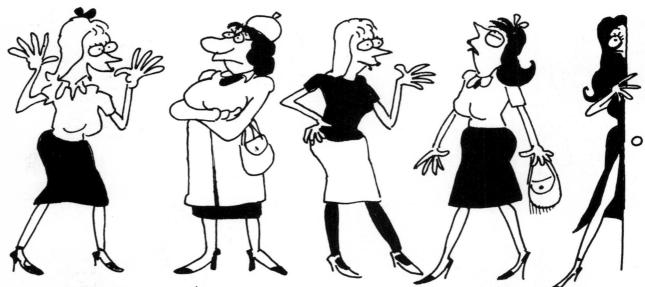

FIX IN YOUR MIND'S EYE HOW PEOPLE REACT TO SITUATIONS...

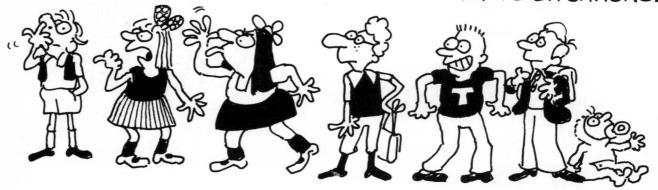

WATCH PEOPLE AT WORK — YOU WILL ALWAYS NEED YOUR OWN TYPICAL POSTMAN, MILKMAN, NEWSPAPER DEALER, ETC...

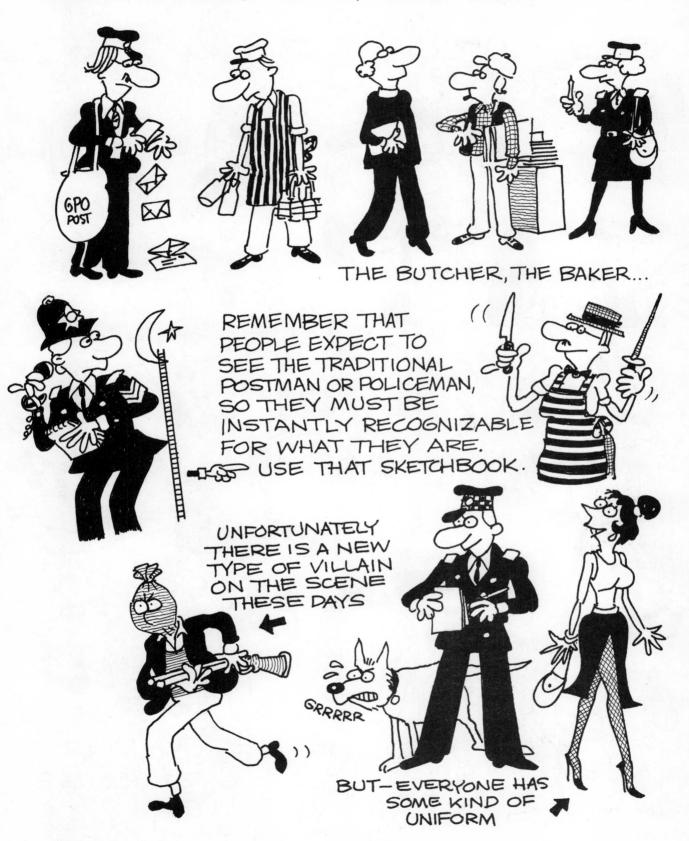

THE BUTCHER, THE BAKER...

REMEMBER THAT PEOPLE EXPECT TO SEE THE TRADITIONAL POSTMAN OR POLICEMAN, SO THEY MUST BE INSTANTLY RECOGNIZABLE FOR WHAT THEY ARE. USE THAT SKETCHBOOK.

UNFORTUNATELY THERE IS A NEW TYPE OF VILLAIN ON THE SCENE THESE DAYS

GRRRRR

BUT—EVERYONE HAS SOME KIND OF UNIFORM

USE YOUR EYES — STUDY PEOPLE, JOT THEM DOWN ON PAPER FOR FUTURE REFERENCE...

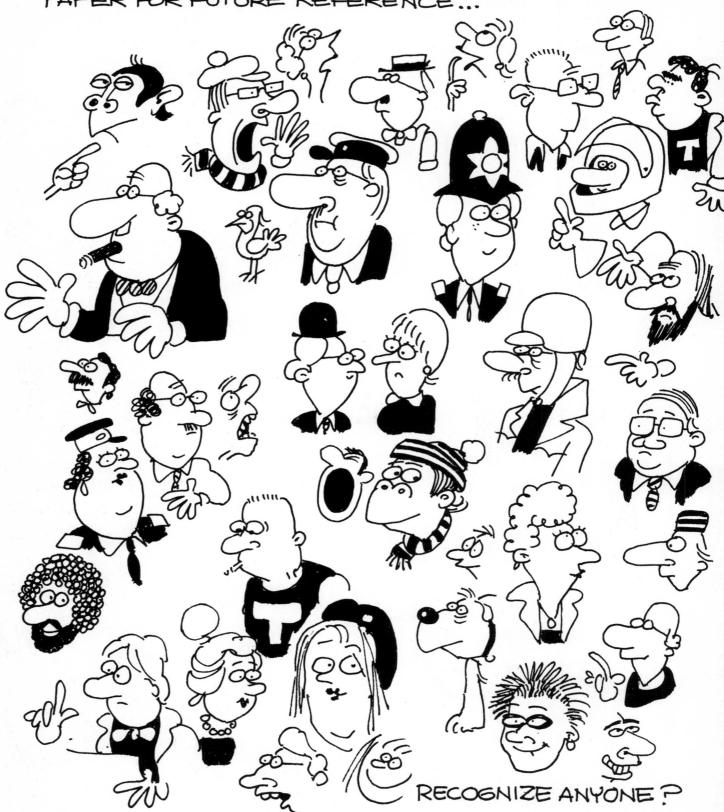

RECOGNIZE ANYONE?

THINK OF ALL THOSE FACES YOU SAW AT THE BUS STOP
THIS MORNING, THAT COUPLE IN THE RESTAURANT
LAST NIGHT...AND LOOK AT HIM GETTING ON THE TRAIN...
—GET THEM DOWN IN YOUR SKETCHBOOK...

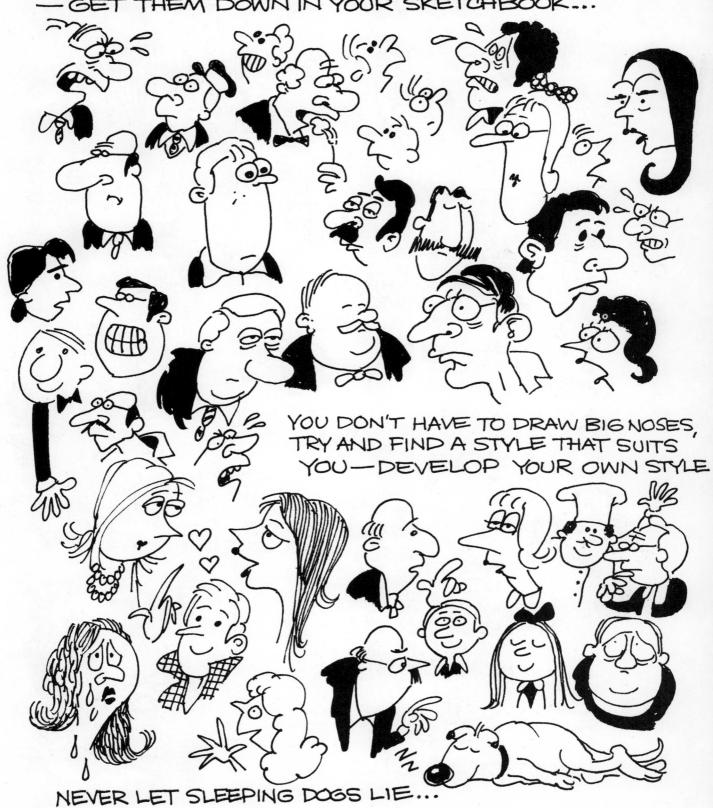

YOU DON'T HAVE TO DRAW BIG NOSES,
TRY AND FIND A STYLE THAT SUITS
YOU—DEVELOP YOUR OWN STYLE

NEVER LET SLEEPING DOGS LIE...

HANDS ARE SO IMPORTANT WHEN IT COMES TO EXPRESSING ACTION — YOU CAN NEVER WASTE YOUR TIME GETTING THESE RIGHT — NOTHING LOOKS WORSE THAN A DRAWING WITH A FIGURE WHO HAS HANDS THE WRONG WAY AROUND.

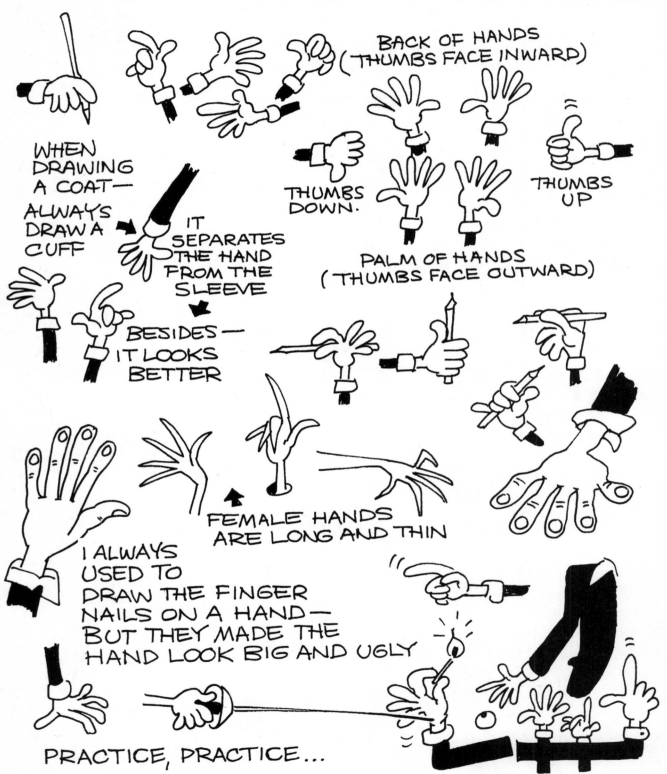

BACK OF HANDS
(THUMBS FACE INWARD)

WHEN DRAWING A COAT —

ALWAYS DRAW A CUFF

IT SEPARATES THE HAND FROM THE SLEEVE

THUMBS DOWN.

THUMBS UP

BESIDES — IT LOOKS BETTER

PALM OF HANDS
(THUMBS FACE OUTWARD)

FEMALE HANDS ARE LONG AND THIN

I ALWAYS USED TO DRAW THE FINGER NAILS ON A HAND — BUT THEY MADE THE HAND LOOK BIG AND UGLY

PRACTICE, PRACTICE...

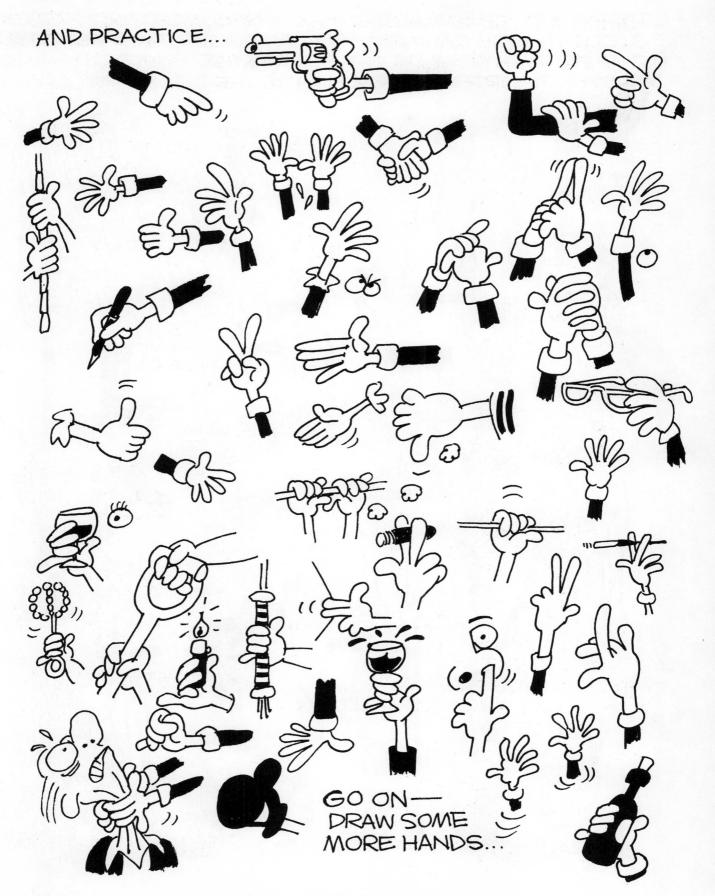

AND PRACTICE...

GO ON—
DRAW SOME
MORE HANDS...

19

FEET—FEET ARE VERY FUNNY THINGS, SO DON'T
NEGLECT THEM — MANY AN EXTRA LAUGH CAN BE GOTTEN
OUT OF FEET, HAVE FUN WITH SHOES AND BOOTS...
FOLLOW THOSE CRAZY FASHIONS...

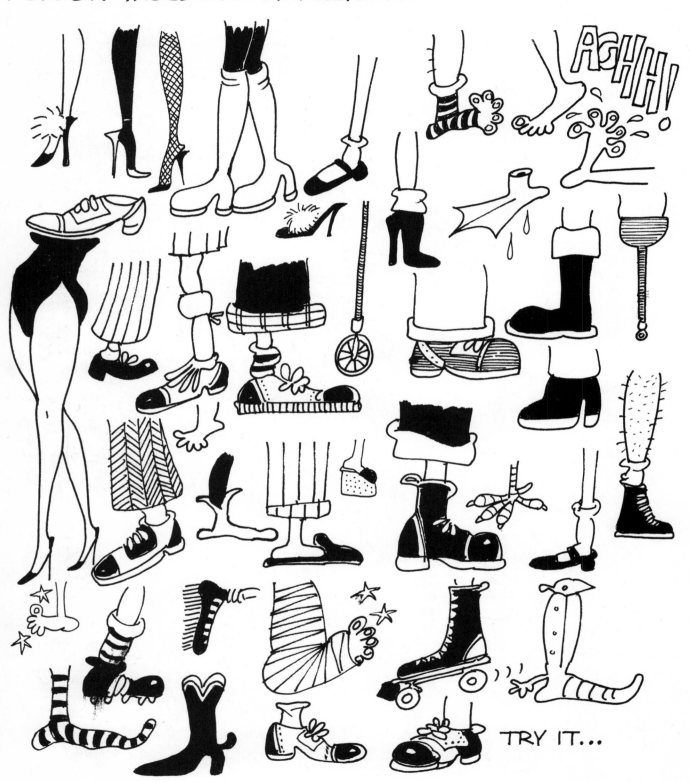

TRY IT...

MAKE NOTES OF THE WAY PEOPLE DRESS—SOME HATS CAN ALMOST TELL YOU WHAT KIND OF FACE GOES BENEATH THEM (THINK ABOUT THAT PARKING LOT ATTENDANT WATCH THOSE FASHIONS—THEY CHANGE SO QUICKLY...

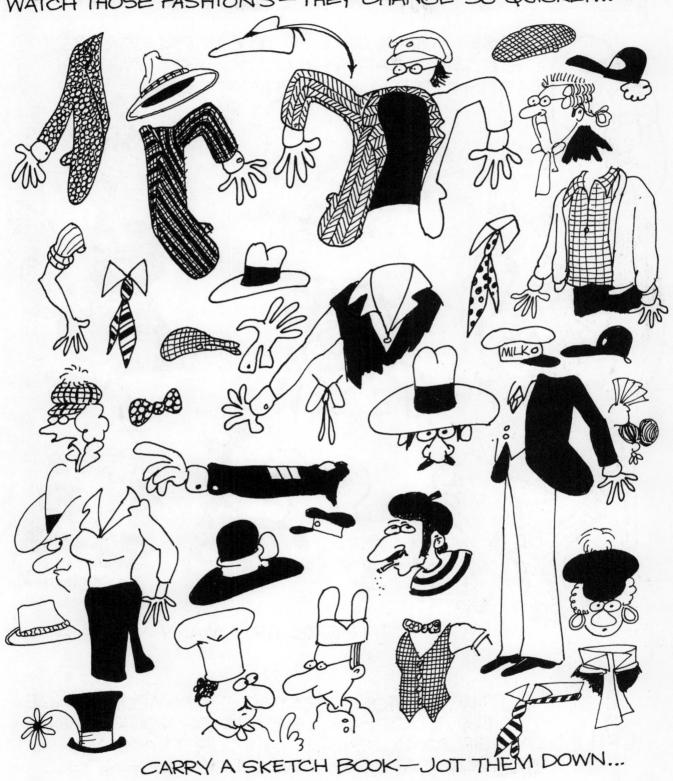

CARRY A SKETCH BOOK—JOT THEM DOWN...

DEVELOPING A STYLE IS NOT EASY—IT TAKES TIME,
BUT WITH HARD WORK AND A BIT OF LUCK IT BECOMES
SECOND NATURE, LIKE YOUR HANDWRITNG—
PEOPLE KNOW IT AND RECOGNIZE IT INSTANTLY.

THESE ARE A FEW OF **MY** IMPRESSIONS
OF SOME LEADING CARTOONISTS WITH A
DISTINCT STYLE OF THEIR OWN...

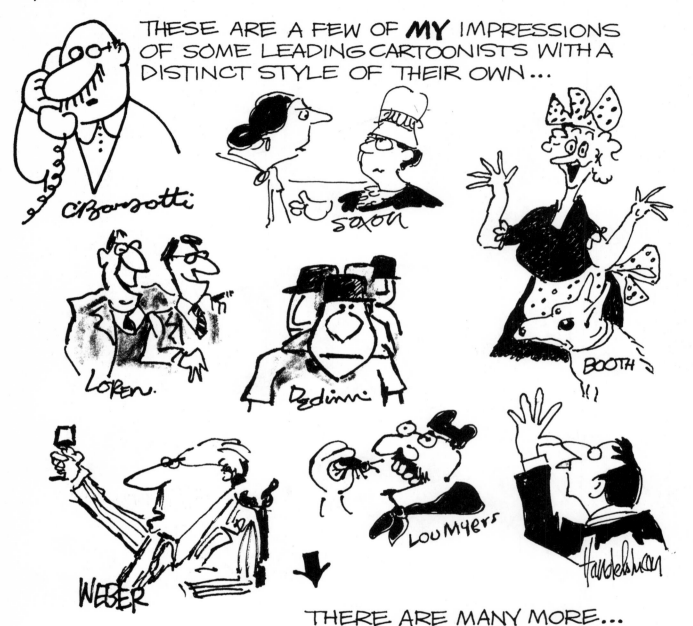

THERE ARE MANY MORE...

BUT IT DEMONSTRATES THE IMPORTANCE
OF DEVELOPING A STYLE OF YOUR OWN—
A PERSONAL STYLE IS YOUR TRADE MARK
SO WORK AT IT—IT WILL PAY DIVIDENDS...

NOW—I CAN'T GIVE YOU A STYLE, BUT CAN SHOW YOU HOW TO GO ABOUT FINDING ONE —
FOR EXAMPLE, MY OWN STYLE IS A BIG NOSE, BALD HEAD AND GLASSES.
DON'T ASK ME WHY—IT JUST WORKED OUT THAT WAY, (I'VE CHANGED MY STYLE ABOUT THREE TIMES OVER THE YEARS…)

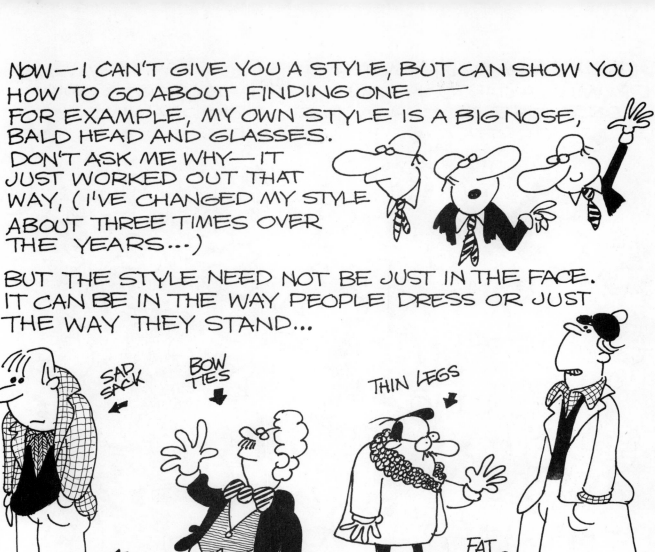

BUT THE STYLE NEED NOT BE JUST IN THE FACE. IT CAN BE IN THE WAY PEOPLE DRESS OR JUST THE WAY THEY STAND…

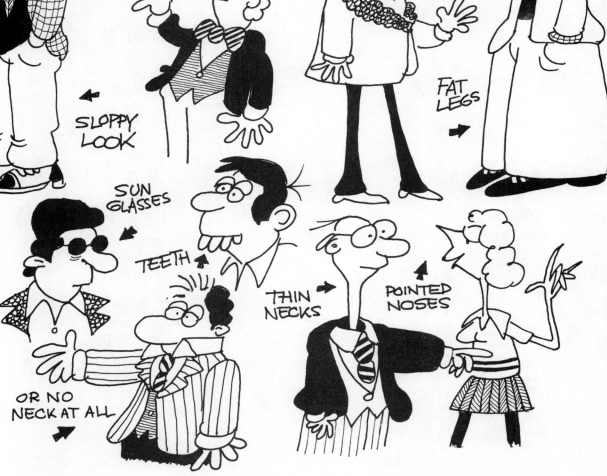

HERE IS A PAGE OF FACES SHOWING VARIOUS WAYS OF DRAWING A CARTOON FACE, PERHAPS THERE'S ONE HERE CLOSE TO YOUR OWN STYLE OF DRAWING...

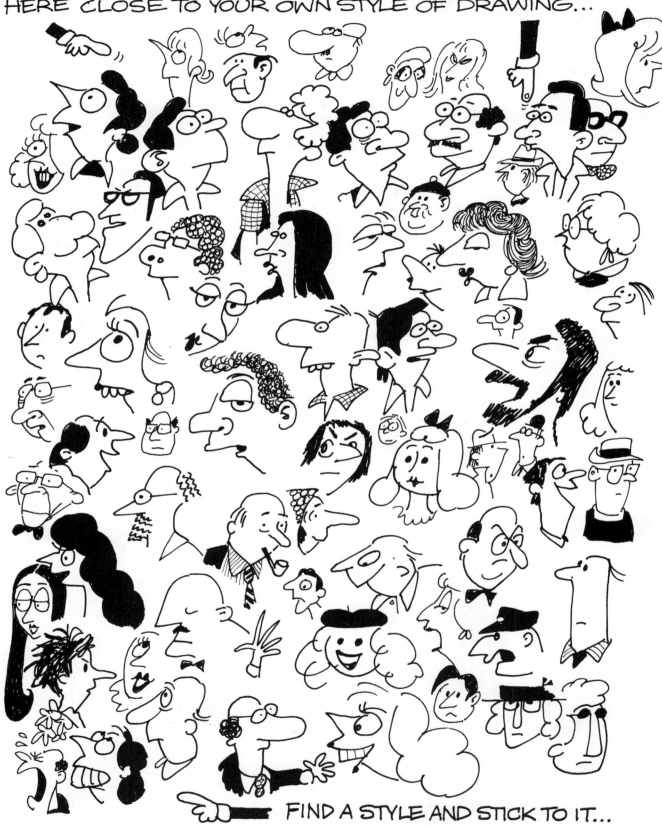

FIND A STYLE AND STICK TO IT...

GIRLS, OF COURSE, WILL ALWAYS SELL CARTOONS, BUT THERE SEEMS TO BE A SHORTAGE OF GOOD GIRLIE ARTISTS THESE DAYS — SO IF YOU CAN DRAW PRETTY GIRLS *NOW IS YOUR CHANCE...

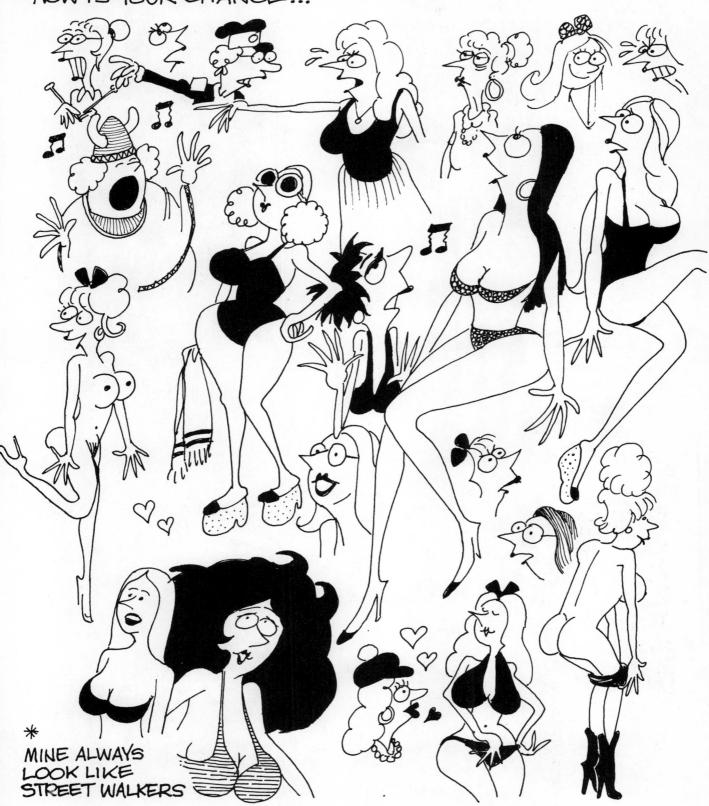

* MINE ALWAYS LOOK LIKE STREET WALKERS

25

TRY PUTTING BIG GIRLS
WITH LITTLE MEN — IT
LOOKS FUNNY AND ALL
YOU NEED IS A GOOD
CAPTION FOR THE GAG...

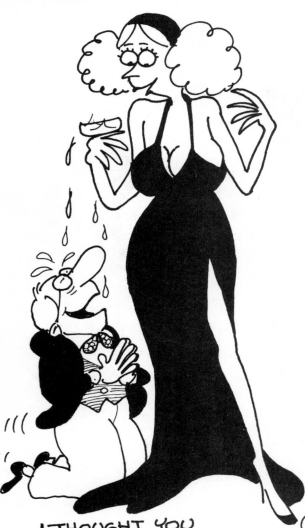

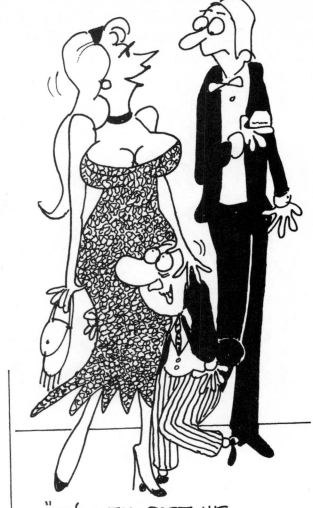

"IT'S WELL PAST HIS
BEDTIME"

I THOUGHT YOU
DIDN'T DRINK?

SEXIST!

OR SOMETIMES NO
CAPTION AT ALL... ➡

THE MORE CARTOONS YOU DRAW, THE EASIER IT WILL
BECOME FOR YOU TO RECOGNIZE THAT YOU HAVE A STYLE
OF YOUR OWN IN THERE SOMEWHERE TRYING TO GET OUT
— THEN ONCE YOU KNOW WHAT IT IS, YOU EXPLOIT IT.
IT WILL TAKE TIME, BUT IT WILL HAPPEN EVENTUALLY.

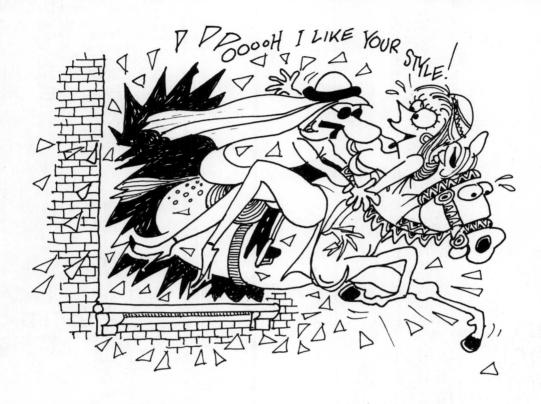

NOW — LET'S GET ON WITH
MAKING A CARTOON...

SCALING UP OR SCALING DOWN IS EASY ENOUGH IF YOU
HAVE CUT OUT THAT FRAME SHEET ——
USE YOUR BLUE PENCIL TO DRAW YOUR FRAME — THEN
DRAW A DIAGONAL LINE FROM THE TOP LEFT HAND CORNER
TO THE BOTTOM
RIGHT — NOW
USING THIS AS A
GUIDE SCALE UP
OR DOWN TO SUIT
YOUR SIZE OF
DRAWING...

BUT IF YOU CAN
STICK TO THE AREA
INSIDE THE FRAME
SHEET — DO SO...

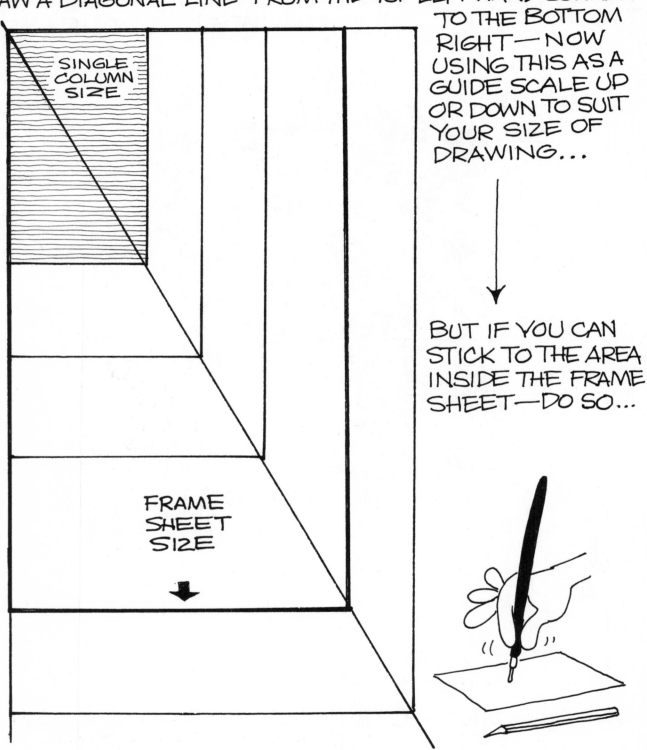

SINGLE
COLUMN
SIZE

FRAME
SHEET
SIZE

DRAW THE FRAME AREA WITH YOUR BLUE PENCIL AND
FRAME SHEET — THEN DRAW A CHARACTER TO FIT
COMFORTABLY WITHIN THE AREA, DON'T MAKE HIM
A TIGHT FIT — MAKE IT SO HE CAN MOVE ABOUT...

ONCE YOU GET USED TO DRAWING AT THIS
SIZE YOU WILL FIND YOU CAN CONTROL
ALL THAT WHITE SPACE...

TRY IT OUT WITH ONE CHARACTER TO START WITH —
DO LOTS OF DRAWINGS UNTIL YOU FEEL HAPPY WITH
THE DRAWING SIZE...

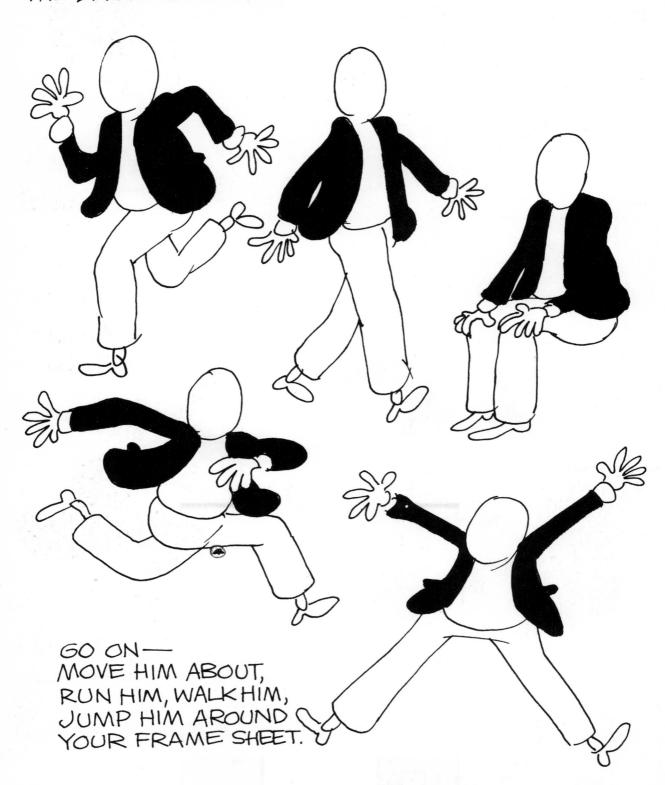

GO ON —
MOVE HIM ABOUT,
RUN HIM, WALK HIM,
JUMP HIM AROUND
YOUR FRAME SHEET.

THEN ADD A SECOND CHARACTER
AND MOVE THEM ABOUT WITHIN
THE FRAME — HAVE FUN BY
PUTTING THEM IN DIFFERENT
SITUATIONS — TRY ONE LARGE
AND ONE SMALL CHARACTER—
ONE FAT, ONE THIN — DRAW
THEM IN FUNNY POSITIONS...
GO ON, ENJOY YOURSELF

* DON'T FORGET THIS IS A BLUE PENCIL LINE

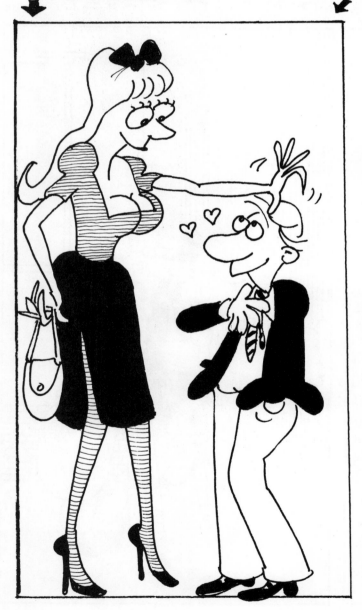

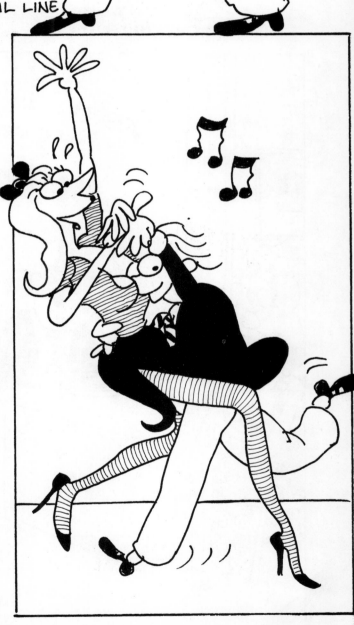

31

NOW TRY DRAWING SITUATIONS —
PUT TWO PEOPLE WITHIN YOUR FRAME AND
ADD A LITTLE BACKGROUND TO SUGGEST
WHERE THEY ARE OR WHAT THEY ARE DOING —
TRY AND MAKE USE OF ALL THE FRAME AREA.

ECONOMY — THAT'S THE KEYWORD HERE,
TRY NOT TO OVERLOAD THE BACKGROUND,
OTHERWISE YOU WILL SWAMP YOUR CHARACTERS.

A COUPLE TALKING
IN A RESTAURANT...

A COUPLE WALKING
DOWN A CITY STREET...

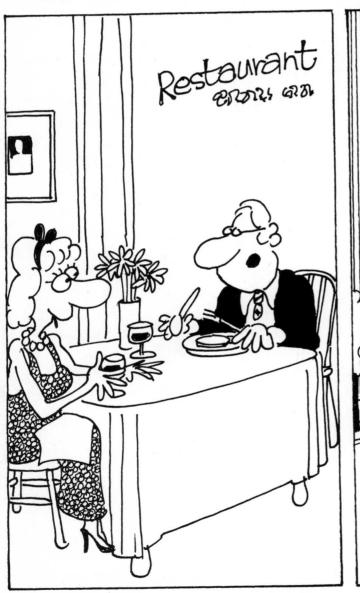

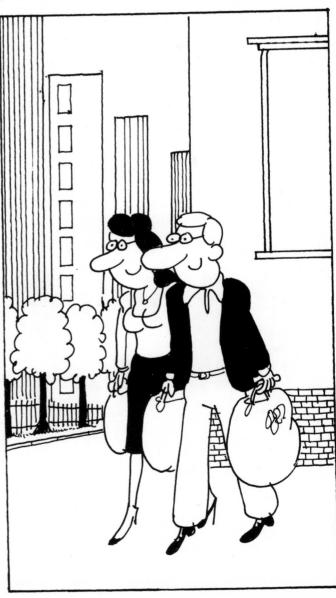

I AM WELL AWARE THAT THIS IS AN AWKWARD SHAPE
TO DRAW IN— AND HOW MUCH BETTER IT IS TO FORGET
THE FRAME SHEET AND DRAW AT RANDOM—
BUT REMEMBER THIS, MOST CARTOON EDITORS WILL
BUY BY SIZE ALONE — IF IT FITS HIS SPACE IN THE
MAGAZINE OR NEWSPAPER HE'LL USE IT— REJECT
SLIPS ARE EASY ENOUGH TO RETURN WITHOUT YOU
GIVING HIM YET ANOTHER REASON FOR RETURNING
YOUR CARTOONS, SO START WITH A SINGLE
COLUMN DRAWING AND LEARN TO DISCIPLINE
YOUR PEN...

A WAY AROUND THIS PROBLEM IS TO DRAW TO A
* DOUBLE COLUMN SIZE— DRAW TWO PANELS
OFF THE FRAME SHEET AND YOU HAVE A SQUARE—
BUT YOU HAVE A LOT OF SPACE TO FILL ...

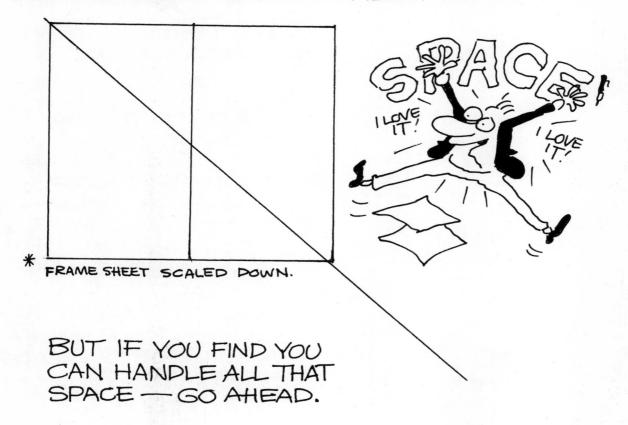

* FRAME SHEET SCALED DOWN.

BUT IF YOU FIND YOU
CAN HANDLE ALL THAT
SPACE — GO AHEAD.

HERE IS A EXAMPLE OF THE DOUBLE COLUMN GAG — DRAW YOUR CARTOON WITHIN A SQUARE. NOTE THE SIMPLE USE OF BACKGROUND DETAIL JUST TO INFORM PEOPLE WHERE THE ACTION IS TAKING PLACE. THE ORIGINAL SIZE OF THESE IS ABOUT FOUR INCHES SQUARE

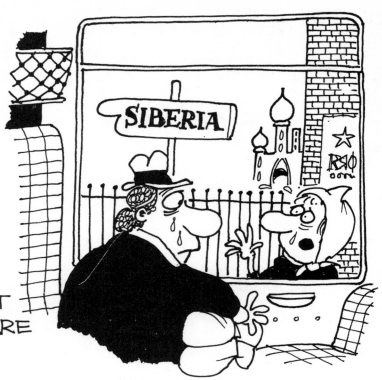

"CHIN UP, TOVARICH —
TAKE IT ALL WITH A PINCH OF SALT!"

WRITE OR PRINT YOUR CAPTION BENEATH THE CARTOON (NOT OVER THE CHARACTER'S HEAD OR COMING OUT OF HIS OR HER MOUTH) — ALSO MAKE IT QUITE CLEAR WHO IS SPEAKING BY GIVING THE CHARACTER A BLACK SPEAKING MOUTH — NO POINT IN LEAVING IT TO A READER TO WORK IT OUT FOR HIM/HERSELF. — SPELL IT OUT!

34

IF ON THE OTHER HAND THE
PROP IS TO BE THE POINT OF
THE JOKE — CUT OUT THE
BACKGROUND ALTOGETHER.
OTHERWISE YOUR DRAWING
WILL SWAMP THE JOKE,
PARTICULARLY IF IT IS A
VISUAL GAG WITH NO
CAPTION — KNOWING HOW
TO USE THAT SPACE WILL
ONLY COME WITH EXPERIENCE.

THE USE OF YOUR BLACKS
IS ALSO IMPORTANT —
DON'T FORGET THOSE
WHITE SPACES AND USE
YOUR FRAME SHEET AS
I HAVE HERE — IT WILL
HELP YOU TO BALANCE
YOUR ARTWORK BY
HAVING AN AREA TO
WORK IN ...

YOU WILL FIND A PARK BENCH VERY USEFUL AS A PROP FOR A GAG — THERE'S MANY A JOKE TO BE GOTTEN OUT OF THIS SITUATION — ALL YOU NEED AS BACKGROUND ARE A TREE, A FENCE AND A PIGEON OR TWO...

IF THE MAIN VISUAL POINT OF YOUR GAG IS SMALL (LIKE THIS ONE) GET CLOSE IN TO YOUR SUBJECT, KEEPING THE DRAWING OPEN AND SIMPLE —
IF YOU DON'T GET IT RIGHT FIRST TIME —
·DO IT AGAIN...

WHERE DO THE IDEAS
COME FROM?

IF YOU CAN TRAIN YOUR MIND TO TUNE INTO SITUATIONS WHERE YOU CAN LET YOUR HUMOR RUN RIOT—YOU'RE IN BUSINESS, NO POINT IN LOOKING AT THAT BLANK PIECE OF PAPER SITTING THERE BEFORE YOU—DRAW SOMETHING ON IT, IF IT DOESN'T WORK OUT—THROW IT AWAY. YOU DIDN'T LIKE THAT PIECE OF PAPER ANYWAY——THIS PIECE IS MUCH BETTER, LOOK I'M DRAWING A CARTOON ON THIS PIECE OF PAPER.

IF A CAPTION FOR A GAG FLASHES INTO YOUR HEAD—WRITE IT DOWN IMMEDIATELY, DON'T PUT IT AT THE BACK OF YOUR MIND, YOU'LL LOSE IT. WRITE IT DOWN UNTIL A PICTURE WILL COME INTO YOUR MIND AND ILLUSTRATE IT. (MANY A GAG LINE HAS COME TO ME JUST AS THE PHONE RANG ONLY TO VANISH FOREVER BECAUSE I DIDN'T WRITE IT DOWN BEFORE I PICKED THAT PHONE UP).

ALWAYS CARRY PEN & PAPER FOR NOTES BECAUSE GOOD GAG IDEAS KNOW NO BOUNDARIES—LEAVE PEN & PAD BY YOUR BEDSIDE, IN THE BATHROOM, ALWAYS BE PREPARED—ORDINARY GAGS WILL ALWAYS BE LURKING ABOUT IN YOUR MIND, BUT EVERY NOW AND THEN YOU WILL GET ONE THAT IS PURE MAGIC—

YOU WILL CONVINCE YOURSELF FOR THAT DAY THAT YOU ARE A GENIUS—THE FEELING DOESN'T LAST, BUT IT IS A JOY WHEN IT HAPPENS... AND YOU CAN ALWAYS GUARANTEE THAT THE GAG THAT GIVES YOU SO MUCH PLEASURE IS USUALLY A GAG THAT NEVER SELLS—SO, BE WARNED.

TO BE A CARTOONIST YOU NEED TO
THINK IN PICTURES OR IF YOU HEAR
A FUNNY GAG LINE — PUT A PICTURE
TO IT.
YOU MUST TRAIN YOUR MIND TO THINK
UP CARTOON SITUATIONS BECAUSE
ONCE YOU CAN DIRECT YOUR MIND
TO A SUBJECT — YOU CAN THEN
PICTURE A SITUATION WITH FUNNY
IDEAS ON THAT SUBJECT. FOR
EXAMPLE : THINK OF A BUILDING SITE, MEN DIGGING
OR LAYING BRICKS — NOW LET YOUR MIND EXPLOIT
THAT SITUATION AND COME UP WITH A GAG, OR TWO,

OR THREE GAGS, DRAW THEM.
NO MATTER HOW CORNY THEY
MAY SEEM AT THE TIME — AT
LEAST YOU ARE STARTING TO
PRODUCE CARTOONS — TWO
GAGS ? THREE ? NOT BAD —
NOW CHANGE YOUR SUBJECT.
THINK ABOUT TRAFFIC COPS
AND PRODUCE A GAG ON THAT
GROUP ——— CAN'T THINK OF ONE?
DON'T WASTE TOO MUCH TIME ON
EACH SUBJECT — IF YOU CAN'T

THINK OF A GAG, CHANGE YOUR SUBJECT, TRY DEEP
SEA DIVERS — BY WORKING THIS WAY YOU WILL KEEP
YOUR MIND FRESH AND NOT GET BORED AND DEPRESSED
BECAUSE YOU CAN'T COME UP WITH
ANYTHING —— BUT YOU <u>MUST</u> DRAW
SOMETHING, IT'S HOPELESS TO SIT
TURNING HUMOR OVER IN YOUR MIND
WAITING FOR THAT BRILLIANT GAG,
IT DOESN'T WORK THAT WAY — SO
GO ON, TURN THEM OUT, CORNY OR
NOT — AT LEAST YOU ARE PRODUCING
SOMETHING...

TO HELP YOU TO "TUNE IN" HERE IS A LIST OF SUBJECTS FOR YOU TO LET RIP YOUR HUMOR ON —

HOSPITALS, SURGEONS, NURSES, DOCTORS, DOCTOR'S OFFICE, WAITING ROOMS, DENTISTS, FIRING SQUAD, SOLDIERS, TANKS, GUNS, SHIPS, SAILORS PIRATES, SWORDSMEN, CIRCUS, CLOWNS, KNIFE THROWER, CATS LION TAMER, DANCING BEAR, POLICE, PRISONS, BANKS, BANK ROBBERS, MINI CARS, MOTORCYCLES, TRICYCLES, HELL'S ANGELS, POLICE WOMEN, POLICE DOGS, PURSE SNATCHER, SCHOOL, KIDS, TEACHER/KIDS, ROLLER SKATES, TRAIN SET, ACTION MAN, TOYS, WIND-UP TOYS, TOY SHOP, JOKE

SHOP, PET SHOP, JEWELERS MILKMAN, DOORMAN, POSTMAN, WINDOW CLEANER, PRIEST, CHURCH, WEDDINGS, BRIDES, CHRISTENINGS, SALESMEN, SPORT, HIGH JUMP, RUNNERS, POLE VAULT, HORSE RACING, JOCKEY, BASEBALL, FOOTBALL, REFEREE, UMPIRE, ART, ARTIST, ARTIST MODEL, OFFICE, MANAGER, SECRETARY, GOLDMINE, GOLD, COOKING, COOK, WAITER, RESTAURANT, CLEANER, PAINTER, STATUES, ART GALLERY, PAINTINGS, WHEELCHAIR, CRUTCH, PEG LEG, PATENT OFFICE, OUTER SPACE, ROCKET, MOON, KNIGHT, ARMOR,

LIBRARY, BOOKS, BOOKKEEPER,
SCULPTOR, TELEVISION, STUDIO,
RAIN, LAKE, SWIMMING, BOATING,
STORM, STRONG MAN, X-RAY.
➡ MOUNTAIN CLIMBING, PIANO,
ICE SKATES, FISHING, FISH STICKS,
BALLOONIST, SCALES, WEIGHT MACHINE,
BEDTIME STORY, BREAKFAST TABLE,
TELEGRAPH POLES, TELEPHONES, BATH, SHOWER,
OPTICIAN, EYE TEST, ANIMAL TROPHIES, SKYSCRAPER,
GORILLA, CAFE, BEACH, SHARK, MUGGING, PARTY
DRINKING, SIGN PAINTING, FOREST FIRE, TOTEM POLE.

ROCKING CHAIR, MARRIAGE
COUNSELING, JAIL VISITS,
SLOT MACHINES, RUINS, ARABS,
AXE, LUMBERJACK, EXECUTION,
KNITTING, SUBWAY, SUBMARINE,
SALT MINES, HITCH-HIKING, PARROT,
FRONT PORCH, MUD HUT, BUTCHER,
BIRD CAGE, SKI, SNOW, FLORIST,
INDIAN ROPE TRICK, FLOWER SHOW,
CYCLING, FIRST AID, TEENAGERS,
COURTING COUPLES, PUBS,
BAR, WINE DRINKING, MONKS,

FIRE

ANGELS, NUNS, CHOIR BOY, MOTORING, ROAD SIGNS.
SIGNALS, STUDENT DRIVER, STATE TROOPER,
COURT, LAWYERS, BANK MANAGER, GOLDFISH,
FISHMARKET, FISHING, K.G.B,
BATMAN & ROBIN, SUPERMAN,
KING KONG, LONE RANGER,
INDIANS, CHINESE RESTAURANT,
KUNG FU, WRESTLING, BOXING,
ATHLETICS, JAVELIN, DIVING,
FROGMEN, SHIPWRECK, CAMEL,
HIGHWAYMEN, SHEIK, LEGIONNAIRE,
ROBIN HOOD, HUNCHBACK, FAIRIES...

HERS HYMNS

41

JAILBIRDS AND PRISON JOKES ARE FANTASTIC SITUATIONS FOR GAG MATERIAL — I COULD DO A BOOK ON THESE ALONE.
DON'T BE AFRAID TO DRAW JAIL PRISONERS IN STRIPES OR EVEN WITH A BALL AND CHAIN — WE KNOW IT'S OUTDATED BUT I KNOW OF NO EASIER WAY OF IMMEDIATE IDENTIFICATION — ALWAYS REMEMBER THAT A READER WILL GIVE A CARTOON ABOUT FIVE OR TEN SECONDS OF HIS/HER TIME BEFORE TURNING THE PAGE, SO IF HE DOESN'T GET THE JOKE IN THAT PERIOD OF TIME HE WILL GIVE UP, SO IMMEDIATE RECOGNITION OF ANY CHARACTER IS OF MAJOR IMPORTANCE.

* I STILL DRAW A BURGLAR IN A FLAT CAP, A MASK AND A STRIPED SWEATER — AND UNTIL SOMEONE INVENTS A BETTER UNIFORM, I'M STICKING TO THAT FORMAT.

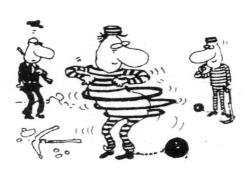

* THE SAME CAN BE SAID FOR DRAWING A PRISON GUARD, — FLAT PEAK CAP, BLACK UNIFORM AND CARRYING A RIFLE — USUALLY SLUNG OVER HIS SHOULDER

 YOU MAY FIND THAT YOU WILL DISCOVER A FAVORITE SUBJECT — EXPLOIT IT... IT'S ALSO VERY USEFUL TO GET YOU STARTED WHEN YOU SIT DOWN TO START A CARTOON SESSION — INSTEAD OF JUST STARING AT THAT BLANK SHEET OF PAPER, START OFF WITH A GAG ON YOUR OWN FAVORITE SUBJECT — JUST ONE GAG WILL GET YOU STARTED IF YOU CAN THINK OF ONE — YOU CAN THINK OF TWO — AND SO ON...

VISUAL GAGS— THE CARTOON WITHOUT A CAPTION IS REALLY THE TRUE CARTOON—AND IF YOU ARE SERIOUS ABOUT BEING A CARTOONIST, DRAW AS MANY VISUAL CARTOONS AS YOU CAN BECAUSE THIS IS HOW YOU CAN LEARN TO GET YOUR HUMOR ACROSS ——NO WORDS— NO CAPTIONS, ONLY YOUR DRAWING... THIS WAY YOU WILL AVOID FALLING INTO THE EASY TRAP OF TWO PEOPLE TALKING TO EACH OTHER —NO NEED FOR ANY ARTWORK, AN EDITOR COULD PRINT ONLY THE CAPTION—— NOT SO WITH THE VISUAL DRAWING, IT'S ALL IN THE ARTWORK.

IT ISN'T EASY, BUT IF YOU GET THE RESULT YOU AIM FOR IT'S FAR MORE REWARDING— AND DON'T FORGET, IF IT'S GOOD, IT CAN SELL ANYWHERE IN THE WORLD BECAUSE THERE ARE NO LANGUAGE BARRIERS.

THINK HOW THOSE WONDERFUL SILENT FILMS HAVE SURVIVED THE TEST OF TIME — YOU CAN PUT A VISUAL GAG IN A DRAWER FOR TWENTY YEARS AND SOMEONE WILL GET A SMILE OUT OF IT WHEN HE OPENS IT...

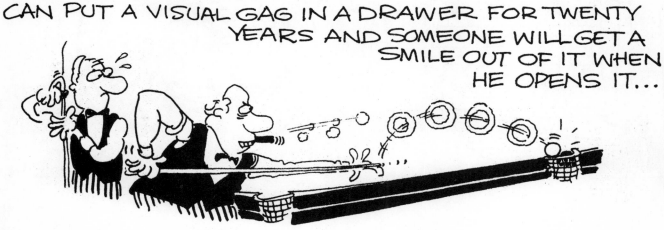

TRY DRAWING A FEW VISUAL GAGS...

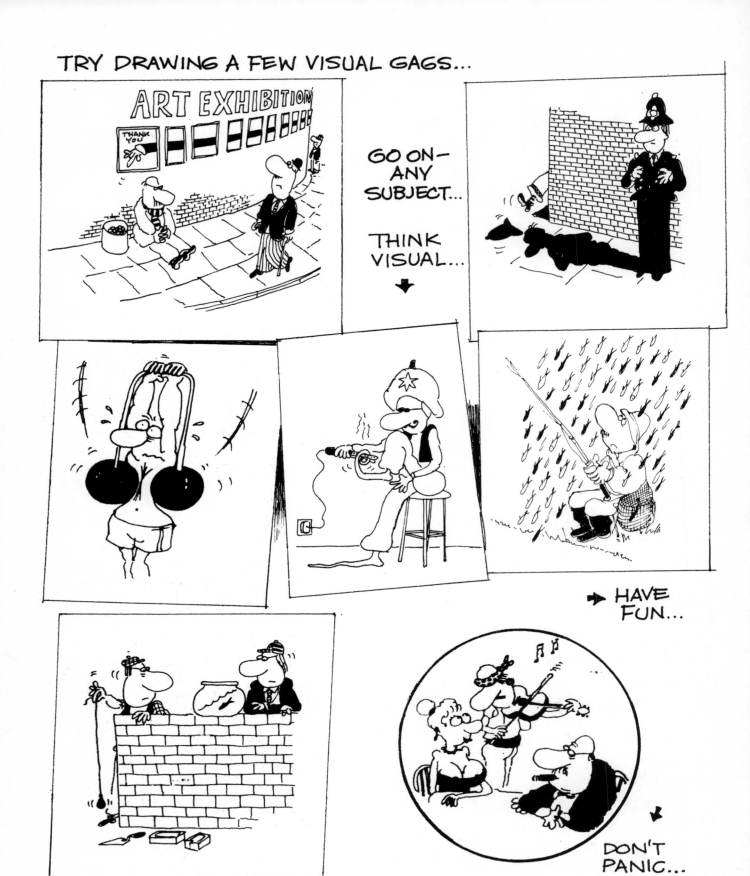

GO ON – ANY SUBJECT...

THINK VISUAL...

HAVE FUN...

DON'T PANIC...

Restaurant

OPEN UP
YOUR MIND

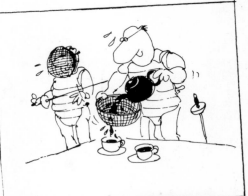

CATCHING
PNEUMONIA

...AND LET RIP
WITH YOUR PEN...

YOU WILL NOTICE
THAT IN THE FIRST
CARTOON THERE IS A SIGN
ON THE WINDOW THAT
SHOULD BE THE OTHER WAY
AROUND TO BE CORRECT.
I DON'T APPROVE OF USING
MIRROR WRITING ——
EVERYTHING MUST BE
IMMEDIATELY CLEAR TO
THE READER—NOTHING
MUST DISTRACT FROM
THE POINT OF THE JOKE

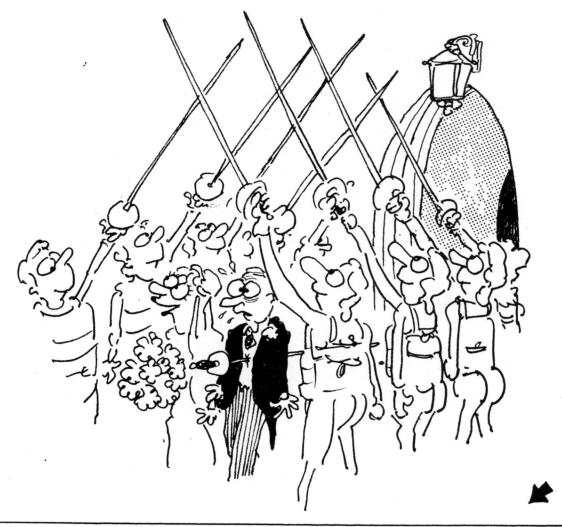

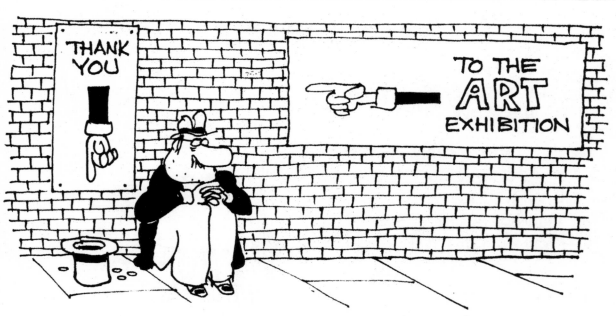

SOMETIMES JUST TO THROW A LITTLE MORE LIGHT ON YOUR SUBJECT—YOU MAY NEED TO SPELL YOUR VISUAL GAG OUT BY USING A SIGN OR TWO—THAT'S OK.—BUT DON'T OVERDO IT...

DON'T PANIC — REACH FOR THE PRO WHITE — THIS IS A THICK WHITE PAINT YOU CAN BLOB ON OVER BLACK INK — JUST PLONK IT ON WITH A BRUSH AND CORRECT YOUR MISTAKE...

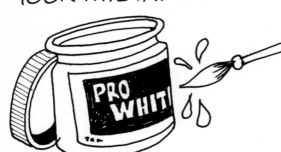

IF ON THE OTHER HAND YOU'VE MADE A MAJOR BLUNDER HAVING JUST DRAWN A CROWD OF TEN THOUSAND...

JUST CUT OUT A PATCH OF FRESH PAPER THAT WILL FIT OVER THE OFFENDING PART...

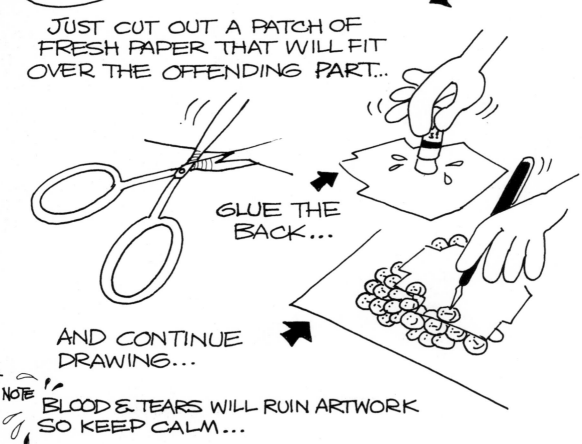

GLUE THE BACK...

AND CONTINUE DRAWING...

* NOTE BLOOD & TEARS WILL RUIN ARTWORK SO KEEP CALM...

TINT

IF YOU WANT TO INDICATE A TINT ON YOUR ARTWORK — MAKE USE OF YOUR BLUE PENCIL — JUST COLOR IN THE AREA THAT REQUIRES TINT AND THE BLOCKMAKER (PRINTER) WILL DO THE REST. (YOU HOPE)

IF YOU WANT TO LAY YOUR OWN TINT, USE ONE OF THE RANGE OF LETRASET TINTS — LAY IT ON AS INSTRUCTED AND CUT YOUR SHAPES WITH A SHARP KNIFE

(BLUE PENCIL IS EASIER)

❉ TRY LETRASET INSTANTEX .12 YOU JUST RUB THAT ON.

ANOTHER FORM OF SHAPING IS PRODUCED BY *CROSS HATCHING, THE SIMPLEST FORM OF SHADING WITH A PEN — USE A FINE POINT FOR THE BEST EFFECT...

* NOT VERY GOOD ON CHEAP NEWSPRINT — SO BE WARNED...

Hello

OH LOOK

Grrr...

PHEW!

A FINE POINT IS Good FOR LETTERING TOO

0·50

0·25

0·35

* FINE POINT PENS

BUT IT IS GOOD FUN...

50

AN IDEA FOR A GAG CAN HIT YOU WHEN YOU LEAST EXPECT IT—SO BE PREPARED, DON'T THINK YOU CAN CARRY AN IDEA AROUND IN YOUR HEAD UNTIL YOU GET TO YOUR DRAWING BOARD, BECAUSE YOU WON'T— SOMETHING ELSE WILL BLOCK IT OUT FOR EVER SO WRITE IT DOWN, EVEN IF YOUR POCKETS DO GET LITTERED WITH BITS OF PAPER IT DOESN'T MATTER. FOR WHEN YOU DO DECIDE TO DRAW IT YOU MAY GET A FRESH OUTLOOK ON IT—BUT YOU MUST HAVE THE ORIGINAL NOTE TO START WITH.

DON'T BE TOO ANXIOUS TO DISMISS AN IDEA — DRAW IT UP, TAKE A LOOK AT IT A COUPLE OF DAYS LATER, IF IT DOESN'T WORK—YOU'LL PROBABLY SEE WHY.— MANY A GAG I COULDN'T STAND THE SIGHT OF IS THE VERY GAG AN EDITOR WILL PICK. I'VE GOT A CUPBOARDFUL OF MY FAVORITE GAGS THAT HAVE YET TO SEE THE LIGHT OF DAY

SO TAKE HEART— YOU'RE NOT ALWAYS THE BEST JUDGE OF YOUR OWN WORK...

51

HERE IS A SAMPLE OF EXPLOITING ONE CAPTION—
IF YOU LET YOUR IMAGINATION RUN RIOT YOU WILL BE
SURPRISED HOW MANY VISUAL SITUATIONS YOU CAN
SQUEEZE OUT OF A ONE LINE GAG CAPTION...

— HAD YOUR EYEFUL?

HAD YOUR EYEFUL?

HAD YOUR EYEFUL?

HAD YOUR
EYEFUL?

"MY GOODNESS,
ISN'T HE LIKE
HIS DAD..." ←

"MY GOODNESS,
ISN'T HE LIKE
HIS DAD..." →

"THIS IS MY FINAL APPEAL FOR DONATIONS TO REPAIR THE CHURCH ROOF"

"THIS IS MY FINAL APPEAL FOR DONATIONS TO REPAIR THE CHURCH ROOF"

STUDY THE CAPTIONS, AND IF A PICTURE COMES TO MIND — PUT IT ON PAPER, WRITE THE CAPTION UNDERNEATH AND YOU'VE GOT YOURSELF A CARTOON —— GO ON, GIVE IT A TRY...

USE YOUR FRAME SHEET ➤

◀ BLUE PENCIL

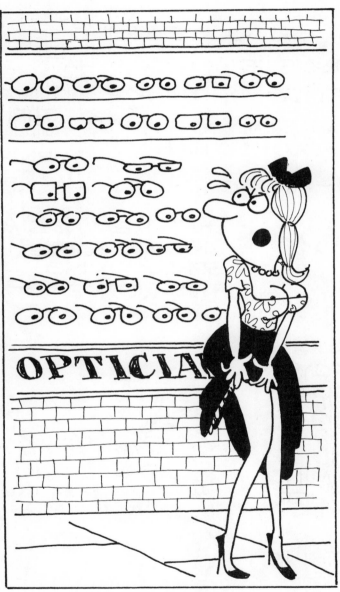

'HAD YOUR EYEFUL?'

ALWAYS WRITE THE CAPTION BELOW THE ARTWORK ➤

WHEN WRITING CAPTIONS, TRY TO KEEP THEM SHORT AND TO THE POINT — THERE ARE EXCEPTIONS OF COURSE BUT THE SHORTER THE CAPTION, THE BETTER THE GAG.

HERE IS A SELECTION OF CAPTIONS TO SET THE IMAGINATION GOING — YOU'LL BE AMAZED HOW MANY VARIATIONS ON A THEME YOU CAN GET OUT OF ONE SIMPLE CAPTION...

TRY IT... "HAD YOUR EYEFUL?" —"I'LL TAKE IT"

"STEP OUTSIDE AND SAY THAT" "RELAX"

"WELL—WHAT DO YOU THINK?" "LEFT HERE— THEN FIRST RIGHT"

"THE LAST TIME I SAW YOU YOU WERE ABOUT SO HIGH"

"TURN YOUR FACE TO THE WALL"

"LAST ONE IN—FIRST ONE OUT"

"MIRROR MIRROR ON THE WALL..." "THAT REMINDS ME— ARE WE GOING SPELUNKING THIS WEEKEND?"

"WE BROKE UP"

"STEP ON IT, WOMAN— WE'RE AN HOUR LATE ALREADY"

"WOULD YOU AND YOUR FRIEND MIND USING THE OTHER BAR..."

"HOLD EVERYTHING — IT HAS SIDE EFFECTS"

"LEFT A BIT— RIGHT A BIT"

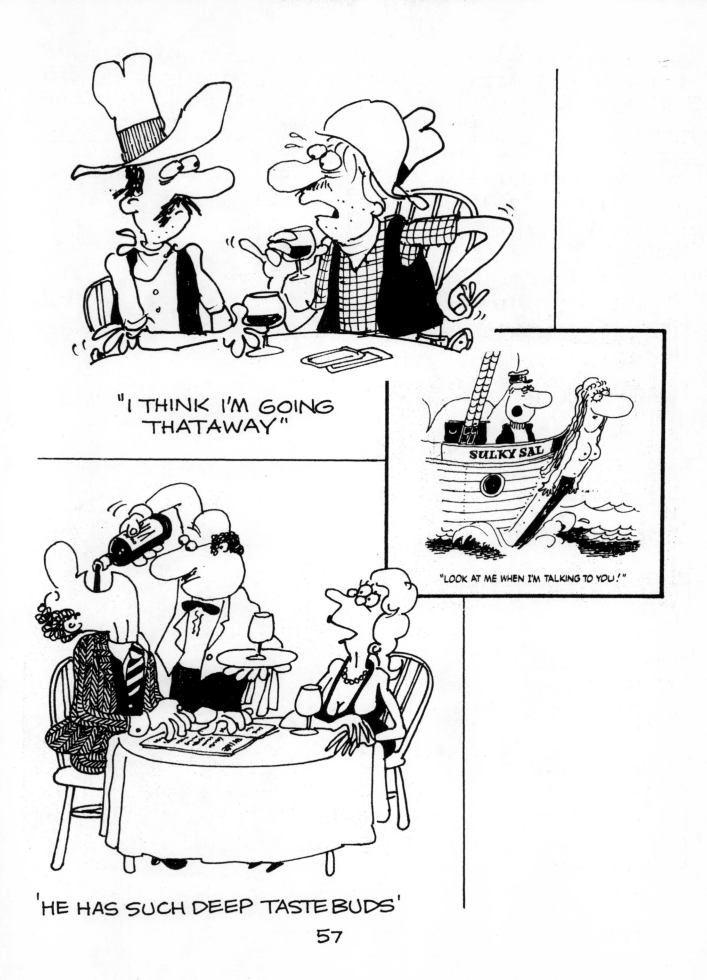

"I THINK I'M GOING THATAWAY"

"LOOK AT ME WHEN I'M TALKING TO YOU!"

'HE HAS SUCH DEEP TASTE BUDS'

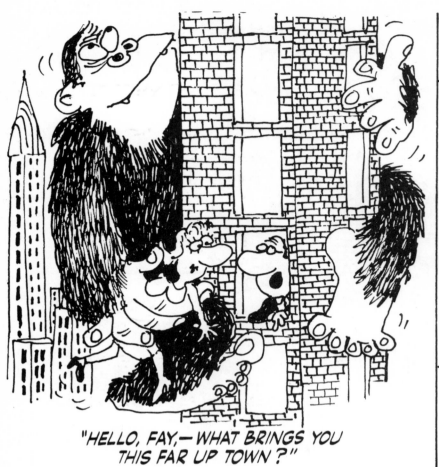

"HELLO, FAY,—WHAT BRINGS YOU THIS FAR UP TOWN?"

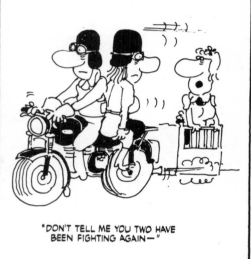

"DON'T TELL ME YOU TWO HAVE BEEN FIGHTING AGAIN—"

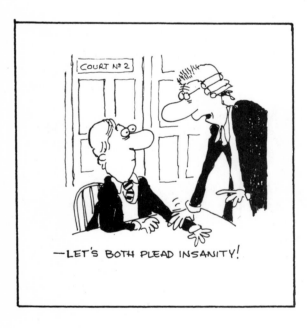

COURT Nº 2

—LET'S BOTH PLEAD INSANITY!

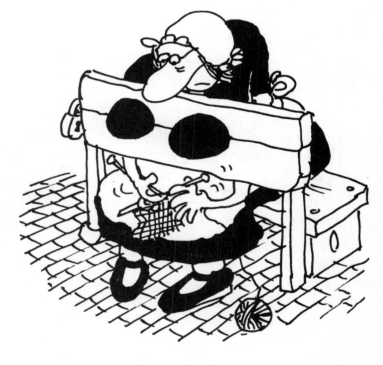

"HERE ARE SOME MORE CAPTIONS FOR YOU TO ILLUSTRATE..."

"WHICH OLD BOOT DO YOU MEAN, SIR?"

"I AM THE GHOST OF CHRISTMAS YET TO COME"

"HE MAKES ALL HIS OWN BEER"

"ALL I'VE EVER BEEN TO YOU IS SOMEONE TO LIE NEXT TO"

"I GAVE YOU THE BEST YEARS OF MY LIFE"

"I THOUGHT THIS WAS SUPPOSED TO BE THE RUSH HOUR?"

"GIVE ME A RING SOMETIME"

"YOU'RE LEADING WITH YOUR RIGHT AGAIN"

"I'M SORRY, DEAR, BUT WE'VE GOT TO CUT BACK SOMEWHERE"

"WOULD YOU MIND — ONLY I'VE LOST MY DIPSTICK"

"HIM SPEAK WITH FORKED FINGERS"

"DO YOU HAVE A CREDIT CARD, SIR?"

"CAN I HAVE A WORD WITH THE LITTLE WOMAN?"

"CALL YOURSELF A DRIVER?"

"WOULD YOU MIND TAKING THAT KICK AGAIN..."

IDEAS

"ARE YOU A QUALIFIED DOCTOR?"

ANIMALS ARE GREAT CHARACTERS TO USE IN CARTOONS—YOU CAN HAVE A LOT OF FUN WITH THEM...

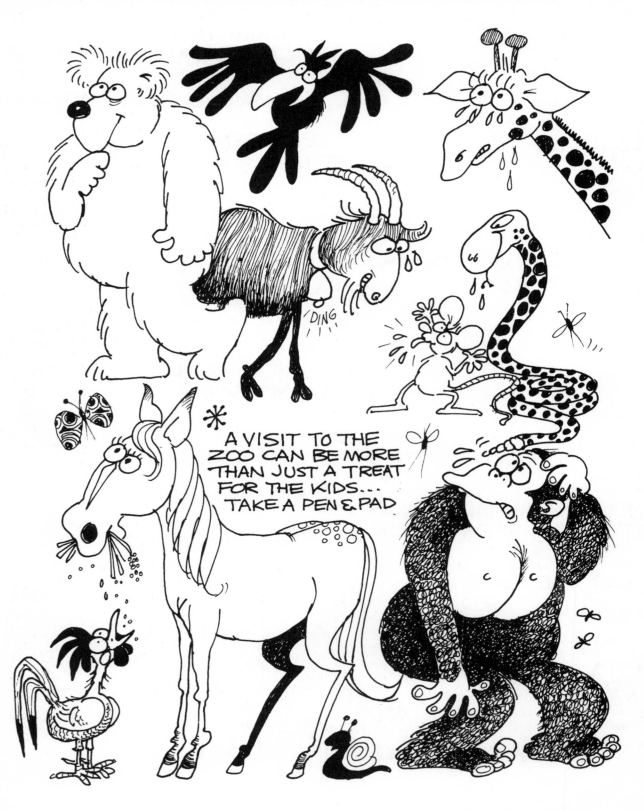

A VISIT TO THE ZOO CAN BE MORE THAN JUST A TREAT FOR THE KIDS... TAKE A PEN & PAD

I LOVE USING ANIMALS IN CARTOONS. THEY CAN CREATE A LOT OF FUN FOR ALL AGES — YOU ONLY HAVE TO THINK OF SNOOPY AS AN EXAMPLE...

HONESTLY—YOU'D BE AMAZED HOW MANY OF US HUMANS ARE ANIMAL LOVERS...

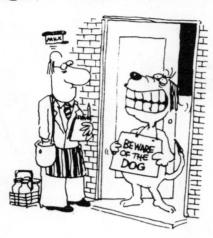

HE HATES INDIANS!

HAVING A LOVELY TIME WISH YOU WERE HERE

DON'T TELL ME—I'VE GOT YOUR NAME ON THE TIP OF MY TONGUE!

KEEP YOUR EYE ON HIM—HE'S A POLITICAL PRISONER!

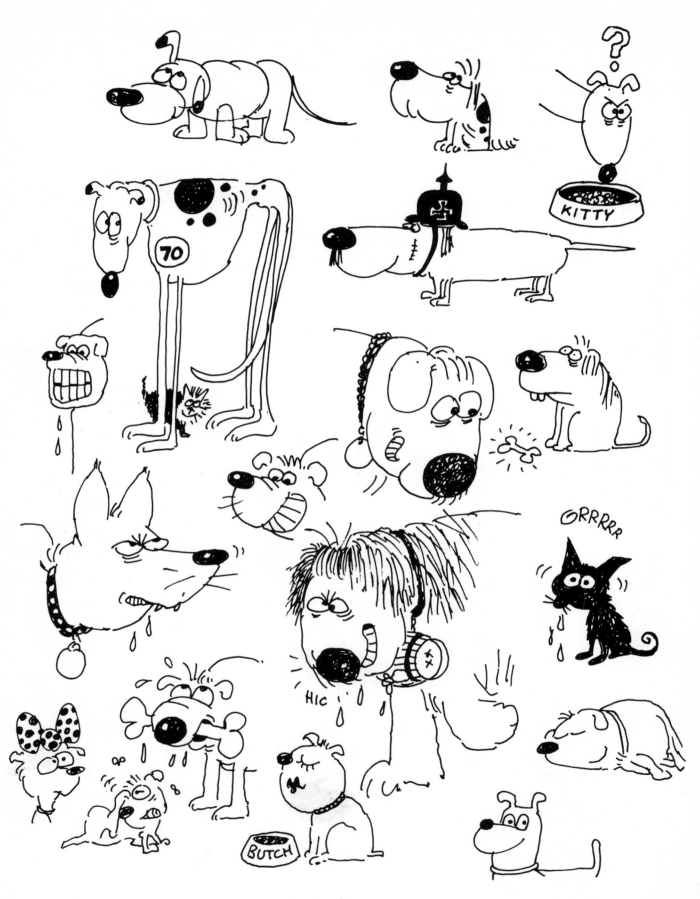

TO MAKE YOUR CARTOONS LOOK MORE INTERESTING TRY TO VARY THE ANGLE OF YOUR ARTWORK — TAKE AN ANGLE FROM ABOVE OR BELOW FOR A CHANGE — SWITCH THE EYE LEVEL ... BE WARNED, IT'S NOT AN EASY THING TO DO AND DONE BADLY IT WILL LOOK TERRIBLE...

BUT IT'S WORTH A TRY...

REMEMBER NOT TO LOSE THE POINT OF YOUR DRAWING... THE ONE ON THE LEFT IS NOT A CARTOON BUT IT DOES ILLUSTRATE AN ANGLE SHOT — AND YOU **ARE** AWARE OF WHAT IS ABOUT TO HAPPEN.

THE STRIP CARTOON IS GREAT TRAINING GROUND FOR THIS KIND OF DRAWING BECAUSE YOU NEED TO CHANGE THE ANGLE IN ANY SITUATION TO KEEP THE ACTION OF THE STRIP INTERESTING TO LOOK AT — BUT IT CAN ALSO GIVE A SINGLE CARTOON DRAWING A LOT MORE IMPACT...

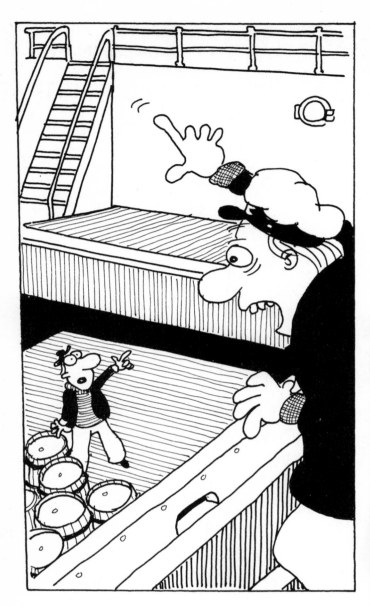

BOOK ILLUSTRATION
IS IDEAL FOR USING
THIS TECHNIQUE.
COLLECT PHOTOGRAPHS
OF UNUSUAL ANGLES
THEN ADAPT THEM
TO CARTOON
ILLUSTRATION ...

IT'S ALL GREAT
EXPERIENCE AND
WILL PAY DIVIDENDS
BY IMPROVING YOUR ARTWORK.

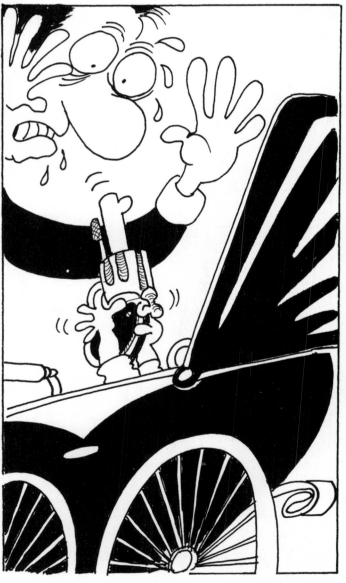

THINK UP A CARTOON
SITUATION WHERE YOU
CAN EXPLOIT AN ANGLE
—— USE IT AS THE MAIN
POINT OF YOUR GAG, FOR
EXAMPLE:
A SMOKE STACK,
A SHIP'S HOLD,
A BUILDER'S CRANE,
PARACHUTISTS...

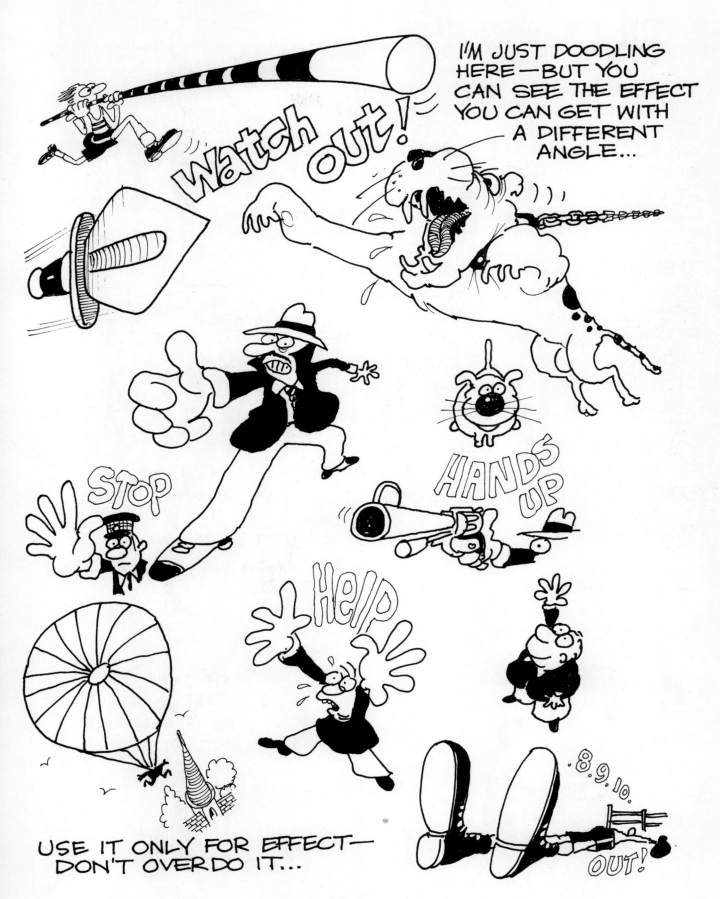

THE TOPICAL CARTOON

THE CARTOON THAT FOLLOWS
THE NEWS IN YOUR DAILY NEWSPAPER
IS A VERY SPECIALIZED FORM OF
CARTOONING — SO UNLESS YOU
ARE A WORKING JOURNALIST OR A
RELATIVE OF THE EDITOR OF YOUR
LOCAL NEWSPAPER, I DON'T ADVISE
SUBMITTING ANY TOPICAL CARTOONS.

THE LIFE OF A TOPICAL CARTOON
IS VERY SHORT, EVEN FOR THE
PROFESSIONAL, AND DON'T
FORGET HE HAS LEARNED THE
TRICK OF PICKING OUT THE
STORY THAT THE MASSES WILL
BE AWARE OF NEXT DAY.

THREE WEEKS AGO—
THIS WAS A VERY FUNNY
TOPICAL CARTOON...

YAWN

SO BE ADVISED AND STICK TO THE
GENERAL GAG CARTOON, AND WAIT UNTIL
YOU ARE INVITED TO SUBMIT A TOPICAL CARTOON

WHAT'S THE
WREATH FOR?

THAT THREE
WEEK OLD TOPICAL
CARTOON OF YOURS

RIP

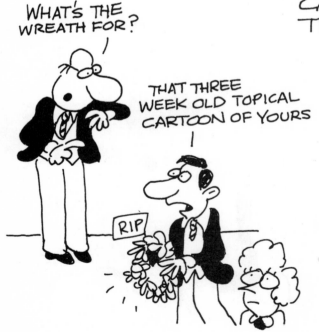

HOURS OF TOIL AND LABOR
CAN BE AVOIDED BY FOLLOWING
THIS ADVICE —

✱ ALWAYS REMEMBER
— YESTERDAY'S
NEWS IS DEAD AND
BURIED...

?
O
R.I.P.

66

HOWEVER, IF YOU ARE ASKED TO SUBMIT ROUGHS
FOR A TOPICAL CARTOON FEATURE — BEWARE
OF TALKING HEADS, TRY TO PUT SOMETHING
VISUAL INTO EACH CARTOON, OTHERWISE YOU
MAY AS WELL PRODUCE THE ABOVE CARTOON
DRAWING EVERY DAY WITH A DIFFERENT
CAPTION WRITTEN BENEATH IT

THE SPORTS CARTOON

THE SPORTS CARTOON SEEMS TO HAVE LOST FAVOR OVER THE YEARS — BUT IT'S STILL A FANTASTIC AREA FOR CARTOON HUMOR, AND I'M CONVINCED THAT IT WILL RETURN TO THE SPORTING PAGES AGAIN AS SOON AS EDITORS BEGIN TO NOTICE HOW GRAY THE PAGES LOOK WITHOUT IT.

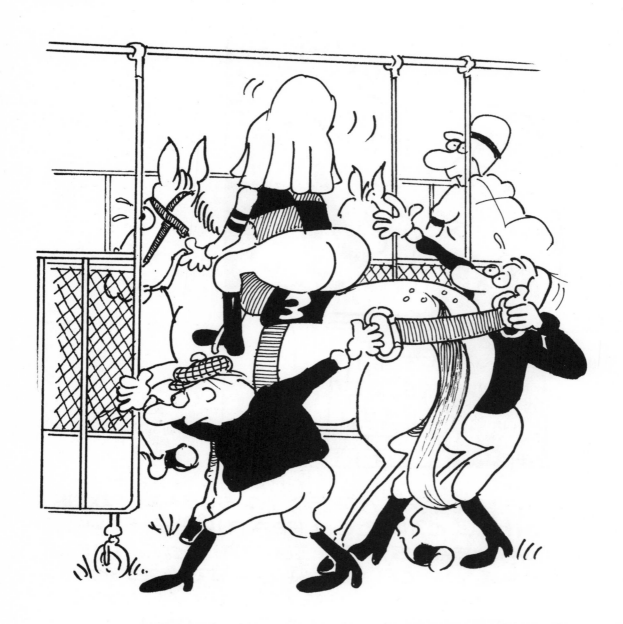

THE FOLLOWING PAGES GIVE YOU A SAMPLE OF HOW WIDE THE SUBJECT IS...

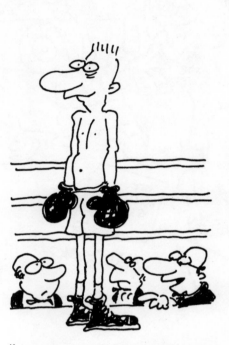

"WITH THOSE FEET, HE'LL NEVER CATCH HIM —"

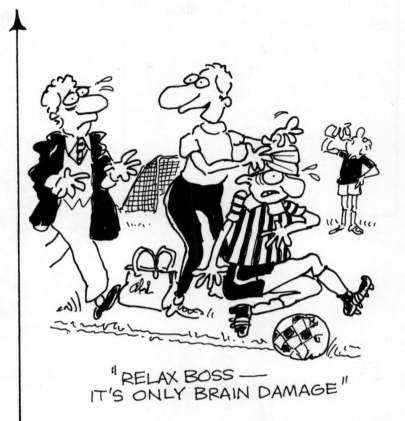

"RELAX BOSS — IT'S ONLY BRAIN DAMAGE"

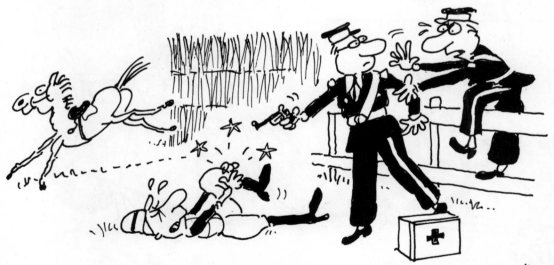

"HORSES — SOMETIMES — JOCKEYS, NEVER!"

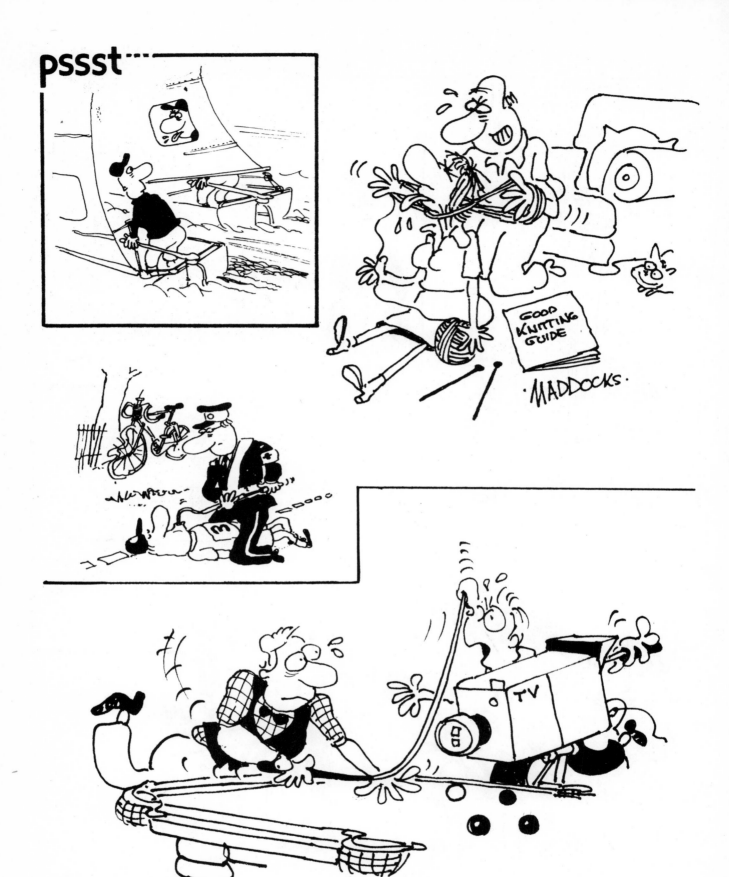

70

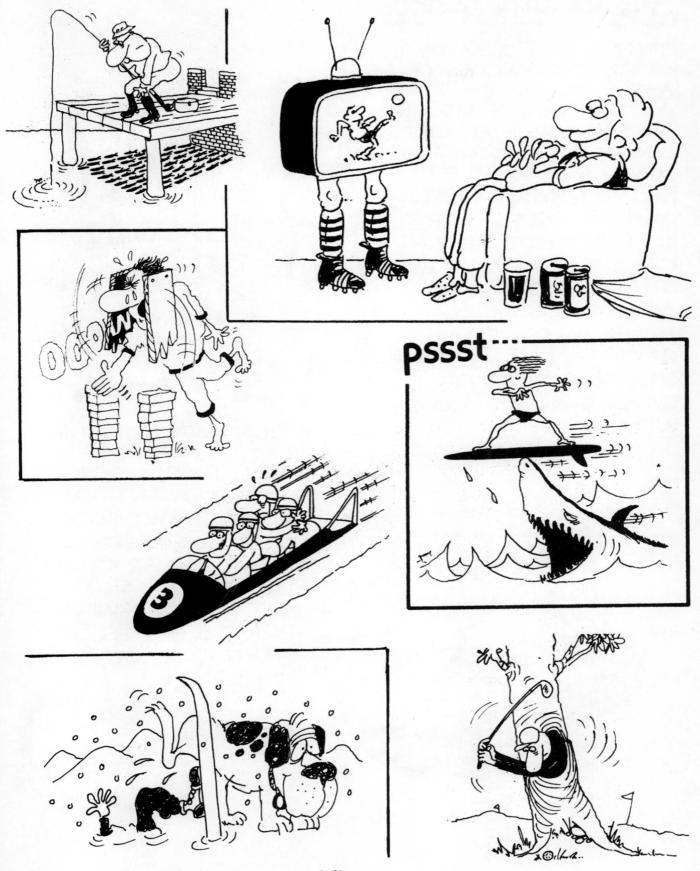

pssst...

THE NAUGHTY CARTOON

THE NAUGHTY OR SAUCY CARTOON HAS COME OF AGE THROUGH THE PAGES OF THE "GIRLIE" MAGAZINES. AT ONE TIME, YOU WERE LUCKY IF YOU COULD DRAW A BREAST—LET ALONE DRAW A NIPPLE. THE KEY-WORD HERE IS RUDE BUT NEVER CRUDE. I ALWAYS SAY THAT IF A CARTOON MAKES YOU LAUGH—HOW CAN IT BE OFFENSIVE?. ON THE OTHER HAND, IF IT SHOULD MAKE YOU WINCE——?

DON'T RUN AWAY WITH THE IDEA THAT YOU CAN GET AWAY WITH ANYTHING IN THIS FIELD, YOU CAN'T—AND YOU WOULD BE WASTING YOUR TIME TRYING—THERE IS A LIMIT BY LAW WHAT YOU CAN GET INTO PRINT—SO DON'T GO PRACTICING DRAWING PRIVATE PARTS OF THE ANATOMY...

LOOK— HAVE YOU EVER SEEN ANYTHING
MORE CURIOUS THAN THAT?

LET RIP WITH YOUR IMAGINATION
— BUT REMEMBER YOU ARE
TRYING TO MAKE PEOPLE
LAUGH, NOT SHOCK OR
NAUSEATE THEM.
DON'T THINK YOU CAN SELL
A NAUGHTY CARTOON ANYWHERE,
YOU CAN'T—— MOST NEWSPAPERS
STILL CATER TO A FAMILY
READERSHIP. DESPITE THOSE
PAGE THREE NUDES THEY STILL
HAVE VERY CONSERVATIVE VIEWS
WHEN IT COMES TO PUBLISHING
CARTOONS —— SO DRAW THAT
SAUCY CARTOON FOR THE
MAGAZINE MARKET...

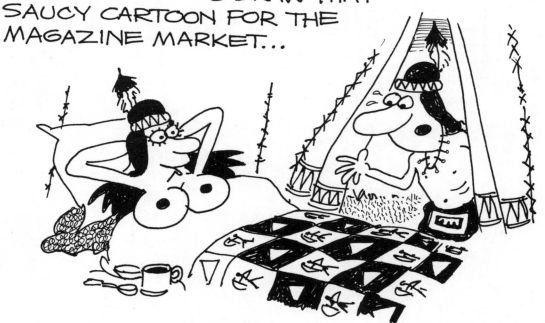

—IS IT TWO MOONS ALREADY?

YOU HAVE MORE FREEDOM WHEN IT COMES TO SPACE.
SIZE DOESN'T REALLY MATTER, HOWEVER IF YOU
DRAW IT TOO BIG YOU'LL NEVER GET IT THROUGH
THE MAIL. AND DON'T TRY COLOR IN THE VERY
BEGINNING — WAIT UNTIL YOU HAVE SUCCESS WITH
YOUR BLACK & WHITE DRAWINGS — THEN SUBMIT
A COLOR CARTOON IF YOU THINK YOU CAN
HANDLE IT...

IF YOU LIKE THE IDEA OF USING COLOR, THE GIRLIE MAGAZINES ARE THE BEST MARKET—— BUT BE WARNED, THE REJECTION PERCENTAGE IS VERY HIGH —— ALWAYS A GOOD PLAN TO WAIT AND BE INVITED TO DRAW COLOR, LESS SWEAT AND TEARS THAT WAY —— CIRCULATE THE GIRLIE MAGAZINES WITH YOUR BLACK AND WHITE DRAWINGS AND PLAY SAFE. THE NAUGHTY CARTOON IS ALWAYS IN GREAT DEMAND AMONG YOUR FRIENDS, THEY MAKE GREAT GET WELL OR GREETING CARDS——

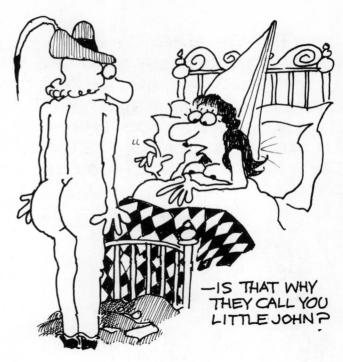

—IS THAT WHY THEY CALL YOU LITTLE JOHN?

A GREAT TONIC FOR A SICK FRIEND IN THE HOSPITAL, OR A BIRTHDAY OR ANNIVERSARY OR EVEN A VALENTINE IF YOU DON'T OVERDO IT. ABOVE ALL, REMEMBER THAT THE HUMOR IS ALL IMPORTANT—— DON'T BE SMUTTY OR OFFENSIVE —— MAKE 'EM LAUGH IF IT'S FUNNY IT WON'T OFFEND——

HONEST!

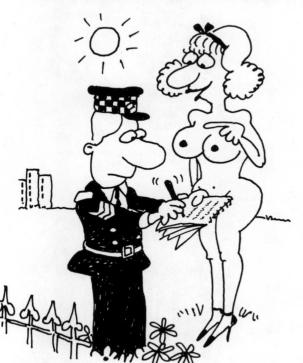

NOT HOUSEWIFE—PUT EXHIBITIONIST

75

THEME GAGS.
THIS IS A SERIES OF RUNNING GAGS
ON ONE PARTICULAR THEME —
COWBOYS, INDIANS, KNIGHTS
IN ARMOR... IF YOU THINK YOU
CAN KEEP IT GOING IT'S WORTH
A TRY... GIVE YOUR CHARACTER OR
FEATURE A TITLE NAME...

DON'T TELL ME YOU'VE LOST THE FRONT DOOR
KEY <u>AND</u> THE KEY TO THE CHASTITY BELT — ?

THIS KIND OF
FEATURE COULD
SELL WEEKLY
OR DAILY...

"SNAP OUT OF IT — A LOT OF US HAVE NEVER
JUMPED FROM A TROJAN HORSE BEFORE..."

'HONESTLY — I'M SORRY ABOUT
YOUR FINGERNAIL !"

I CAN UNDERSTAND THE LIONHEART BIT — BUT
HOW THE BLAZES DID YOU COME TO BE CALLED RICHARD

BUT YOU'D HAVE
TO WORK
KNIGHTS —
(SORRY)

YOU CAN'T GO ON LIKE THIS —
KNIGHT AFTER KNIGHT AFTER KNIGHT !

THE POLITICAL CARTOON

THE POLITICAL CARTOONIST IS A RARE BIRD — VERY SPECIALIZED — AND TO BECOME ONE YOU NEED TO BE NOT ONLY TALENTED AND POLITICALLY INFORMED, IT WOULD HELP IF YOU ARE RELATED TO THE OWNER — BETTER STILL OWNED THE NEWSPAPER YOURSELF.

THIS IS A JOB THAT COMES ALONG MORE BY ACCIDENT THAN DESIGN, WORKING VERY CLOSE TO THE EDITOR (AND HIS POLITICAL THINKING). YOU NEED TO BE WELL INFORMED, HAVING READ, LISTENED TO, AND TALKED TO ALL ON THE POLITICAL SCENE — THERE'S A LOT MORE TO IT THAN BEING ABLE TO DRAW POLITICAL CARICATURES.

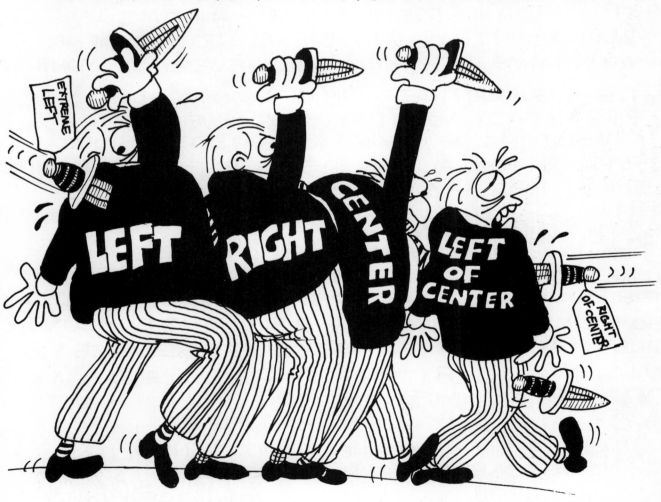

THE EDITOR REGRETS...

↑

THIS IS THE CARTOONIST'S **ENEMY**

→ **AGGH!!!!!!!!!**

☆ IT'S CALLED A REJECTION SLIP—AND TAKE MY WORD FOR IT, YOU WILL BE ABLE TO WALLPAPER YOUR HOME WITH THEM ONCE EVERY SIX MONTHS.

IT'S A GUARANTEED WAY OF RUINING YOUR BREAKFAST, YOUR DAY, YOUR LOVE LIFE, TO SAY NOTHING OF MAKING YOU HATE THAT STUPID POSTMAN WHO ALWAYS SEEMS TO ENJOY STUFFING THEM THROUGH YOUR MAILBOX.

NEVER FEAR. EVEN THE BEST OF THE CARTOONISTS GET THEM—IT'S ALL PART OF THE BUSINESS, IF AT FIRST YOU DON'T SUCCEED... SOMEONE ONCE WROTE—WELL, THAT SOMEONE MUST HAVE BEEN A CARTOONIST, BECAUSE YOU WILL HAVE TO TRY AGAIN, AND AGAIN, AND AGAIN—

NEVER GIVE UP...

SOMEONE SOMEWHERE WILL THINK YOUR CARTOONS ARE FUNNY— **Honestly!**

THE FIRST THING TO KNOW ABOUT MAILING YOUR CARTOONS TO YOUR FAVOURITE MAGAZINE OR NEWSPAPER IS TO PACKAGE THEM CORRECTLY.

THE REASON I ADVISED YOU EARLIER IN THIS BOOK TO MAKE YOURSELF A FRAME SHEET IS TO MAKE CERTAIN THAT YOU DRAW TO A STANDARD SIZE FOR PACKAGING — AND IF YOU ARE CLEVER 👉 YOU HAVE DRAWN YOUR CARTOONS ON STANDARD WHITE TYPING PAPER. THIS WILL PAY DIVIDENDS BY SAVING YOU ALL THAT EXCESSIVE POSTAGE... *HOORAY!*

FOLD

STAMPED & ADDRESSED FOR RETURN

NEVER SEND MORE THAN **SIX** CARTOONS AT A TIME TO ANY MAGAZINE OR ANY NEWSPAPER — A CARTOON EDITOR LOOKS AT MASSES OF CARTOONS DAILY — SO HE'LL BLESS YOU FOR A SMALL SELECTION OF YOUR WORK CORRECTLY PACKAGED — HE'LL GET TO KNOW YOUR STYLE AND YOUR PROFESSIONALISM, BECAUSE YOU WILL ALSO INCLUDE A STAMPED ADDRESSED ENVELOPE FOR A QUICK RETURN — AND WHO KNOWS... HE MAY KEEP **ONE** AND RETURN **FIVE** — NO LETTER, NO FUSS — LET YOUR WORK SPEAK FOR ITSELF — BUY ME.... BUY ME!

THE COMIC STRIP

THE COMIC STRIP

THE COMIC STRIP IS IN A CLASS OF ITS OWN WHEN WE TALK ABOUT CARTOONING —

THE COMIC STRIP IS A WAY OF TELLING A STORY DAY BY DAY, WEEK BY WEEK, HOLDING THE READERS' INTEREST ENOUGH EACH DAY TO ENCOURAGE THEM TO BUY TOMORROW'S NEWSPAPER...

SEE TOMORROW'S DAILY......

YOU NEED ONE OR TWO STRONG CHARACTERS TO DOMINATE THE STRIP — PLUS A BRILLIANT IDEA TO HOLD THE STRIP TOGETHER (THE FIRST IS MUCH EASIER TO ACHIEVE THAN THE SECOND).

THEN, YOU NEED A GOOD STRONG TITLE PLUS AN EDITOR WHO WILL NOT ONLY TAKE IT ON, BUT, GIVE IT AT LEAST SIX MONTHS' TRIAL TO GET THE STRIP ESTABLISHED (IT TAKES AT LEAST TWO YEARS TO CAPTURE REGULAR READERS).

THE GOING IS VERY TOUGH TO SELL A COMIC STRIP —— YOU HAVE TO BE IN THE RIGHT PLACE AT THE RIGHT TIME (EDITORS TEND TO PLAY SAFE AND BUY SYNDICATED MATERIAL). SAD BUT TRUE — HOWEVER, DO NOT BE PUT OFF. IF YOU HAVE A BRILLIANT IDEA FOR A COMIC STRIP — GO AHEAD AND PRODUCE IT, THERE ARE ALWAYS EXCEPTIONS...

COMIC STRIPS SEEM TO BE OUT OF FAVOR AT THE MOMENT—EDITORS FAVOR THE HUMOROUS GAG-A-DAY STRIP, BUT FEAR NOT. IT'S A PHASE THAT WILL PASS... BLAME TELEVISION SOAP OPERAS.

DRAW YOUR ORIGINAL ARTWORK 14¾" X 4½". THIS WILL REDUCE TO THE STANDARD COMIC STRIP SIZE IN YOUR NEWSPAPERS.

THE COP SHOP

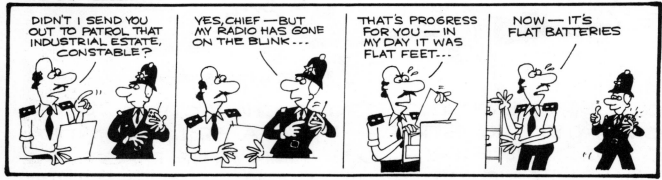

THE STRIP ABOVE ILLUSTRATES THE GAG-A-DAY TECHNIQUE AND THE STRIP BELOW IS THE CONTINUITY STORY STRIP.

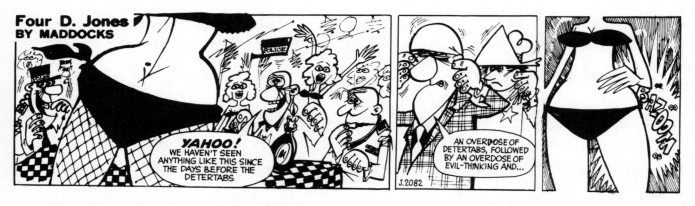

USE PEN AND INK, FIBER TIP (BLACK) OR BRUSH AND INK. WHATEVER SUITS YOU BEST, DRAW ON WHITE BOARD OR TYPING PAPER.—ALWAYS KEEP IN MIND THE REDUCTION AND MAKE GOOD USE OF YOUR SOLID BLACKS, KEEP YOUR DRAWING FREE AND OPEN, BUT ABOVE ALL ACTIVE AND INTERESTING TO LOOK AT—CAPTURE THE READER'S ATTENTION.

——————► A COMIC STRIP NEEDS LIVELY ACTION DRAWINGS, PLENTY OF PACE. MAKE YOUR STRIP LOOK AS IF IT'S GOING SOMEWHERE, GIVE IT PLENTY OF VISUAL ACTION (NOT JUST A SERIES OF TALKING HEADS). THE DIALOGUE NEEDS TO BE CRISP AND AS BRIEF AS POSSIBLE, JUST ENOUGH TO CARRY THE STORY ALONG.—— DON'T OVERLOAD IT WITH A GREAT MASS OF GRAY LETTERING.

TRY TO TELL YOUR STORY IN THREE OR FOUR PANELS EACH DAY, WITH FOUR OR FIVE BALLOONS OF DIALOGUE.

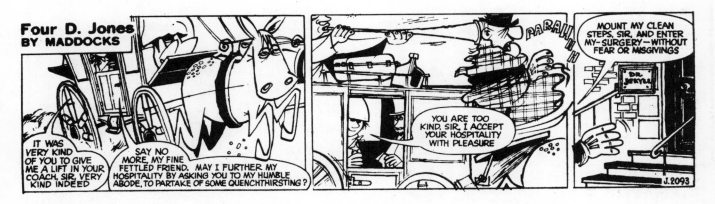

IF YOU CAN'T DO YOUR OWN LETTERING, JUST PENCIL IN THE DIALOGUE AND LEAVE IT TO A PROFESSIONAL—— NOTHING LOOKS WORSE THAN GOOD ARTWORK RUINED BY AMATEUR LETTERING —SO DO A PAPER OVERLAY AND INDICATE WHERE YOU WANT YOUR BALLOONS TO GO AND PENCIL IN THE DIALOGUE ——BUT DON'T FORGET TO LEAVE SPACE FOR THE BALLOONS IN THE ARTWORK.

PAPER OVERLAY.

CONTINUITY IS ALL IMPORTANT—YOU MUST LEARN TO CARRY THE STORY ALONG DAY BY DAY WITHOUT REPEATING YOURSELF —— THE TRICK IS TO JOG THE READER'S MEMORY OVER THE WEEKEND IN THE VISUALS WITH A LITTLE CONTINUITY DIALOGUE ON A MONDAY MORNING TO REFRESH THE READER'S MEMORY...

IF YOU CREATE A COMEDY ADVENTURE STRIP—GIVE YOUR LEADING CHARACTER A FOIL TO TALK TO. YOU WILL FIND IT EASIER TO PLAY OFF A GAG...

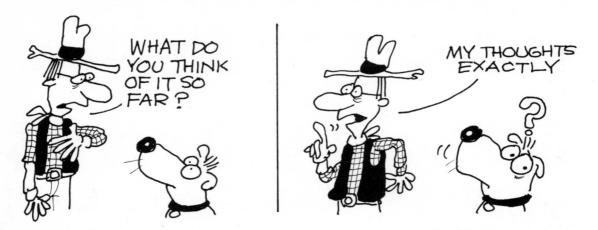

WHAT DO YOU THINK OF IT SO FAR?

MY THOUGHTS EXACTLY

IF YOU DON'T USE A FOIL—YOU WILL HAVE YOUR LEADING CHARACTER TALKING TO HIMSELF OR ELSE FIND YOURSELF LETTERING LOTS OF "THINK" BALLOONS

REMEMBER THAT IF YOU DO SELL A DAILY STRIP TO A NEWSPAPER— WITH LUCK IT COULD GO ON FOR YEARS, SO EXPLORE THE IDEA THOROUGHLY—STUDY YOUR MAIN CHARACTERS...

WHAT'S A THINK BALLOON?

IF YOU THINK THAT YOU HAVE A GREAT IDEA FOR A COMIC STRIP —— START BY PRODUCING TWELVE FINISHED STRIPS (LETTERED) PLUS A SYNOPSIS OF THE FIRST STORY.

Four D. Jones
BY MADDOCKS

JONES HAS BEEN BLOWN UP A TREE

ONCE AGAIN I AM THE VICTIM OF MY OWN STUPIDITY. MY FAITH IN HUMAN NATURE IS RAPIDLY ON THE DECLINE

J.2530

IN FUTURE I SHALL CONSIDER EVERY STEP I TAKE....

YOU MUST UNDERSTAND THAT I, TOO, AM ONLY HUMAN— WHAT'S *YOUR* EXCUSE?

BELOW IS A SAMPLE OF THREE DAYS OF STRIPS...
THE ARTWORK TELLS THE STORY BY USING DIALOGUE
IN BALLOONS — CONTINUITY DIALOGUE IS USED IN
PANELS AT THE TOP OF THE STRIP (A PANEL IS
ALWAYS USED FOR A MONDAY STRIP TO REMIND
READERS OF WHAT HAPPENED IN THE SATURDAY
STRIP BEFORE). TRY NOT TO OVERLOAD THE STRIP.
WITH LETTERING, JUST ENOUGH TO CARRY THE
STORY...

Four D. Jones
BY MADDOCKS

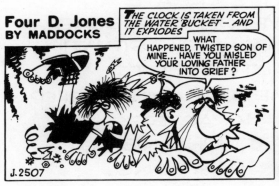
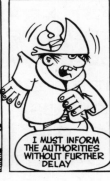
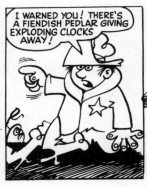
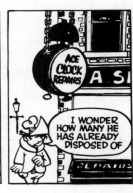

Four D. Jones
BY MADDOCKS

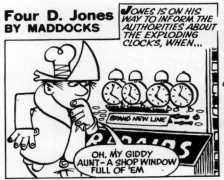
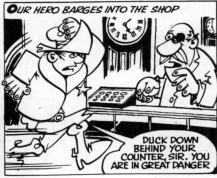
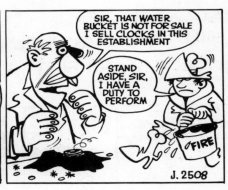

Four D. Jones
BY MADDOCKS

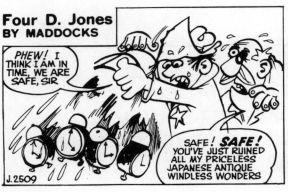
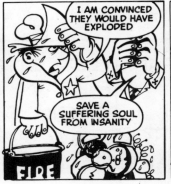
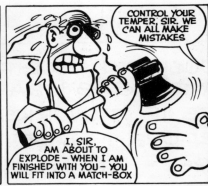

THE GAG STRIP

THE DAILY OR WEEKLY GAG STRIP REQUIRES A DIFFERENT TECHNIQUE FROM THE STORY OR COMIC STRIP.

IT IS BASICALLY AN EXTENSION OF A SINGLE GAG STRETCHED OUT INTO A COLUMN OF THREE OR FOUR PICTURES — EACH STRIP BEING COMPLETE EACH DAY WITH A PUNCH LINE.

THE FIRST THING YOU NEED TO DO IS CREATE A CHARACTER OR A THEME TO DEVELOP YOUR IDEAS. AN OFFICE SITUATION OR A HIS/HER DOMESTIC SITUATION, SCHOOLCHILDREN, ANIMAL CHARACTERS, ETC. HAVING DECIDED ON YOUR THEME AND HAVING WORKED OUT YOUR MAIN CHARACTER OR CHARACTERS — THEN COMES THE DIFFICULT PART, WORKING OUT A STRING OF SITUATIONS — GAG SITUATIONS.

I WORK OUT MY GAGS BY WRITING OUT THE DIALOGUE FIRST (ONCE YOU KNOW WHAT THEY ARE GOING TO SAY, YOU CAN THEN DRAW YOUR CHARACTERS WITH THE RIGHT EXPRESSIONS AND ATTITUDES)...

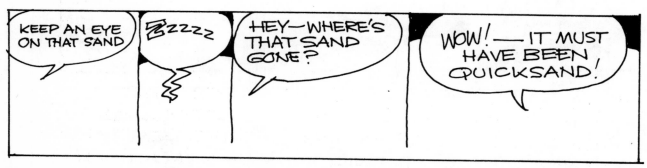

ROUGH OUT YOUR PANEL OR STRIP AND ONCE YOU HAVE A GAG IDEA — WRITE IN THE DIALOGUE TO SEE IF IT WORKS. I DO SIX GAGS THIS WAY BEFORE I START TO DRAW... GET THE GAG RIGHT FIRST — THEN DRAW IT...

WHEN YOU THINK YOU'VE GOT THE DIALOGUE WORKED OUT—THEN WORK ON THE VISUALS...

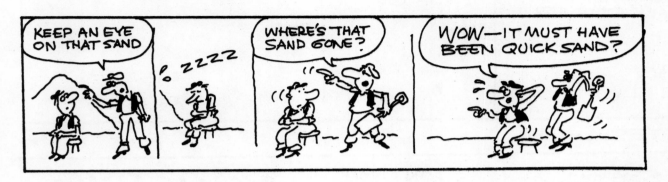

USE A LARGE LAYOUT PAD (24"x 18" approx). IT'S A NICE SURFACE TO WORK ON WITH INK OR A FIBER TIP— IT'S TRANSPARENT ENOUGH TO TRACE THROUGH, SO YOU CAN EASILY MAKE CORRECTIONS.

I SOMETIMES USE IT FOR FINISHED WORK, YOU CAN MOUNT IT ONTO BOARD FOR PRESENTATION.

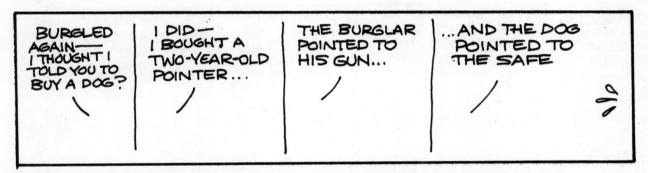

ROUGH OUT THE FRAME OF YOUR STRIP TO SIZE (14¾"x 4½")...THEN WORK OUT ABOUT A DOZEN GAGS BY WRITING THE DIALOGUE — PICK OUT THE BEST AND DRAW THEM UP — YOU WILL FIND THIS TECHNIQUE USEFUL FOR JOTTING DOWN AN IDEA THAT COMES TO YOU WHEN YOU'RE MILES AWAY FROM YOUR DRAWING BOARD — DRAW A FRAME IN YOUR NOTEBOOK AND WRITE DOWN THE DIALOGUE... I FIND A LONG TRAIN JOURNEY IS PERFECT FOR MAKING GOOD USE OF THIS SYSTEM. P.S. BUT IT'S CHEAPER TO DO IT AT HOME!

| GREYHOUND— YOU ALWAYS LOOK HALF STARVED... | DON'T YOU EVER GET... | **HUNGRY?** |

NOTES...

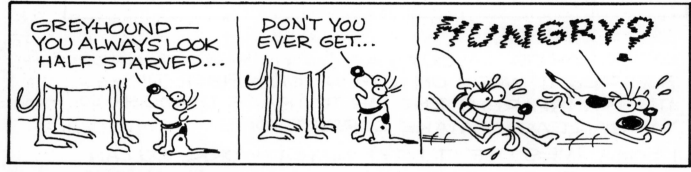

AND SKETCHES...

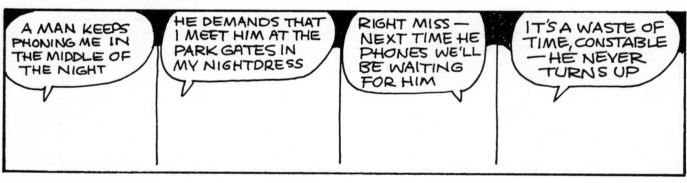

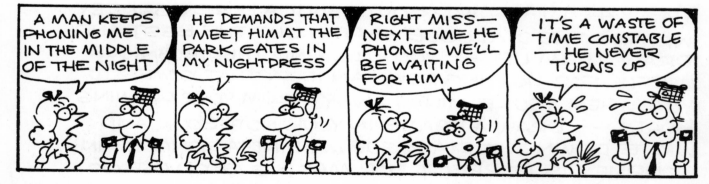

YOU WILL FIND THAT AS YOU GET USED TO USING THIS WAY OF WORKING OUT THE GAGS—ONCE YOU HAVE YOUR CHARACTERS FIXED FIRMLY IN YOUR MIND... THE DIALOGUE WILL FLOW VERY EASILY.—*HONESTLY!*

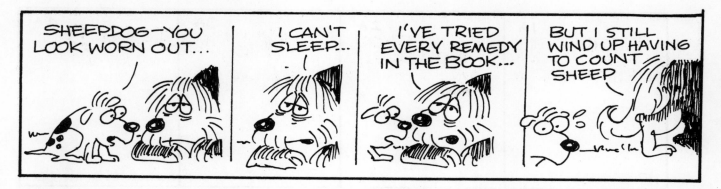

ANIMALS ALWAYS MAKE A GOOD COMIC STRIP—
THERE'S A CAPTIVE AUDIENCE FOR A GOOD ANIMAL STRIP.
A STRONG TITLE IS VERY IMPORTANT, SO GIVE IT A LOT
OF THOUGHT —— DON'T THINK THAT THE VISUALS ARE NOT
IMPORTANT, THEY ARE — MAKE THEM LOOK INTERESTING
ANIMATE YOUR CHARACTERS AS MUCH AS POSSIBLE. TRY
NOT TO MAKE THEM LOOK AS IF THEY WERE DONE
WITH A RUBBER STAMP.

PUT LOTS OF EXPRESSION INTO A GAG-A-DAY STRIP.
MAKE IT LOOK ALIVE...

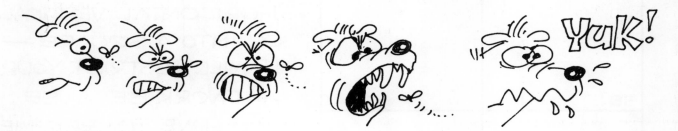

IT DOESN'T HAVE TO BE A DOG—YOU'VE GOT THE WHOLE
ANIMAL KINGDOM TO CHOOSE FROM...

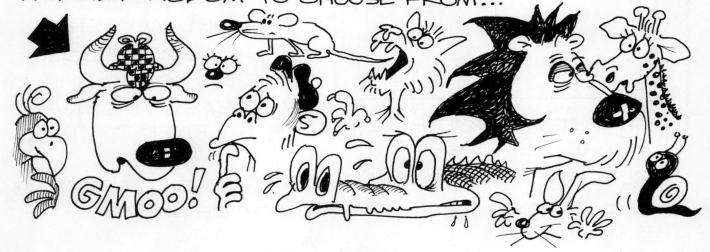

1A	2A	3A	4A
1B			

AN EDITOR MAY WELL COMPLAIN THAT BECAUSE OF THE LACK OF SPACE HE CAN NEVER FIND SPACE IN HIS PAPER FOR A COMIC STRIP —— SO WHY NOT DEVISE A STRIP THAT CAN BE SPLIT INTO SHAPES?

2B	
1C	2C
3B	
3C	4C
4B	

THIS WAY HE CAN ALWAYS FIT THE STRIP INTO ANY LAYOUT HE CHOOSES. HORIZONTAL, VERTICAL OR INTO A SQUARE — IT WILL RESTRICT YOUR ARTWORK, BECAUSE YOU HAVE TO KEEP THE ACTION WITHIN EACH PANEL — HOWEVER, IT DOES MAKE THE STRIP VERSATILE... THE DANGER IS IT IS TOO EASY TO LEAVE IT OUT ALTOGETHER, HAVING NO FIXED POSITION IN THE NEWSPAPER.

BUT IT CAN BE DONE——AND IS WORTH CONSIDERING SHOULD THE PROBLEM BE LACK OF SPACE.

DO I USE BALLOONS FOR DIALOGUE OR NOT?—
WELL— SUIT YOURSELF, SOME STRIPS LOOK GOOD
WITH BALLOONS... OTHERS LOOK BETTER WITH JUST
LETTERED DIALOGUE...

BUT IF YOU DO USE BALLOONS...

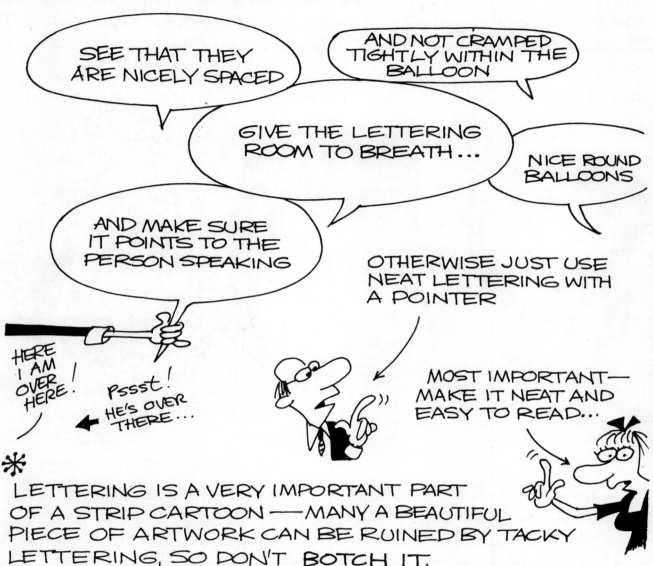

LETTERING IS A VERY IMPORTANT PART
OF A STRIP CARTOON —MANY A BEAUTIFUL
PIECE OF ARTWORK CAN BE RUINED BY TACKY
LETTERING, SO DON'T BOTCH IT.

JUST PENCIL IN THE LETTERING ON
AN OVERLAY OF TRACING PAPER ——ALSO LEAVE
PLENTY OF ROOM FOR THOSE LOVELY ROUND
BALLOONS—— I KNOW I'VE SAID THIS BEFORE, BUT
IT'S WORTH REPEATING...

CARICATURE

THE MOST ASTONISHING THING ABOUT POLITICAL CARICATURE IS HOW THE POLITICIANS SEEM TO GET TO LOOK MORE LIKE THEIR CARTOONS THAN THEIR PHOTOGRAPHS — A LEADING CARTOONIST ALWAYS SEEMS TO LATCH ON TO SOMETHING ABOUT THEM — DRESS, HAIR, NOSE, AND BEFORE YOU KNOW IT IT'S A MAJOR PART OF THEIR CHARACTER...

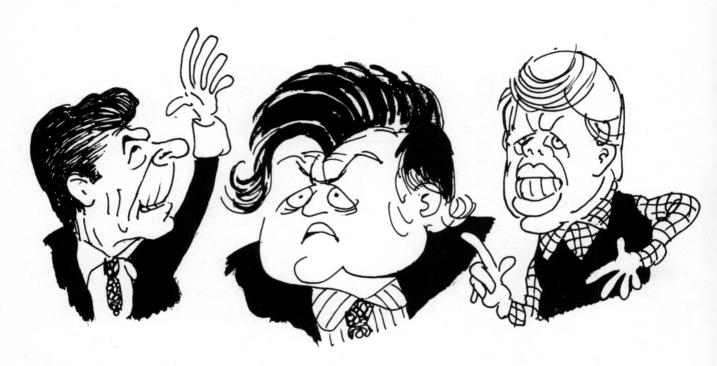

ONCE A NEW POLITICIAN IS ESTABLISHED ON THE POLITICAL SCENE, EVERY CARTOONIST SEEMS TO FIT HIS RECOGNIZABLE FEATURES INTO HIS OWN STYLE OF DRAWING —— OF COURSE THERE'S ALWAYS THE DIFFICULT ONE, A FACE THAT YOU CAN'T DO A LOT WITH — UNTIL SOME BRAVE CARTOONIST BREAKS THE BARRIER BY GETTING A LIKENESS — THEN ONCE YOU CAN SEE THE KEY TO THE LIKENESS, ALL THE OTHERS FOLLOW SUIT — GRATEFULLY...

I KNOW A BRILLIANT CARICATURIST WHO CAN DRAW ANYONE'S LIKENESS WITH A FEW STROKES OF HIS BRUSH — HOWEVER, HE CAN'T DRAW ANYTHING ELSE, HE GOES TO PIECES FROM THE NECK DOWN. HE CAN DRAW A BRILLIANT FACE WITH A PERFECT LIKENESS EVERY TIME — IF HE ADDS A BODY TO THE FACE IT'S A DISASTER, SO YOU SEE IT IS A GIFT, AND ONE THAT IS ALWAYS IN DEMAND. IF YOU HAVE THIS GIFT — WORK ON IT, IT'S A RARE ONE.

GET YOURSELF A SCRAPBOOK OF YOUR SUBJECTS (COLLECT FAMOUS FACES), STUDY THEM, AND DRAW ON FAIRLY THIN PAPER SO THAT YOU CAN TRACE — THE NOSE ON THAT LAST DRAWING MAY NOT BE RIGHT, BUT THE EYES ARE PERFECT. SO TRACE THE EYES AGAIN AND GIVE THE NOSE ANOTHER TRY. SOMETIMES YOU CAN GET IT THE FIRST TIME — THEN AGAIN YOU COULD BE UP TO YOUR ARMPITS IN PAPER... DO NOT DESPAIR, YOU'LL GET IT RIGHT IF YOU WORK AT IT.

CARICATURE A CHARACTER —

IT ISN'T BENNY HILL, BUT IT IS A BENNY HILL CHARACTER...

KEEP THE EXPRESSION IN YOUR HEAD WHEN YOU ARE DRAWING...

AND IF YOU CAN GET IT DOWN ON PAPER — YOU'RE LAUGHING...

CARICATURES MUST ALWAYS SPEAK FOR THEMSELVES. IF YOU HAVE TO IDENTIFY THEM BY NAME, THEN YOU HAVE FAILED. YOU CAN ALWAYS CHEAT AS I HAVE ➡ BY WRITING A CATCHPHRASE

"WHO LOVES YA BABY?"

BUILD UP A FOLDER OF YOUR CARICATURES — SPORTS PEOPLE, STARS, T.V. PERSONALITIES. WELL WORTH SHOWING TO AN EDITOR IF THEY ARE GOOD.

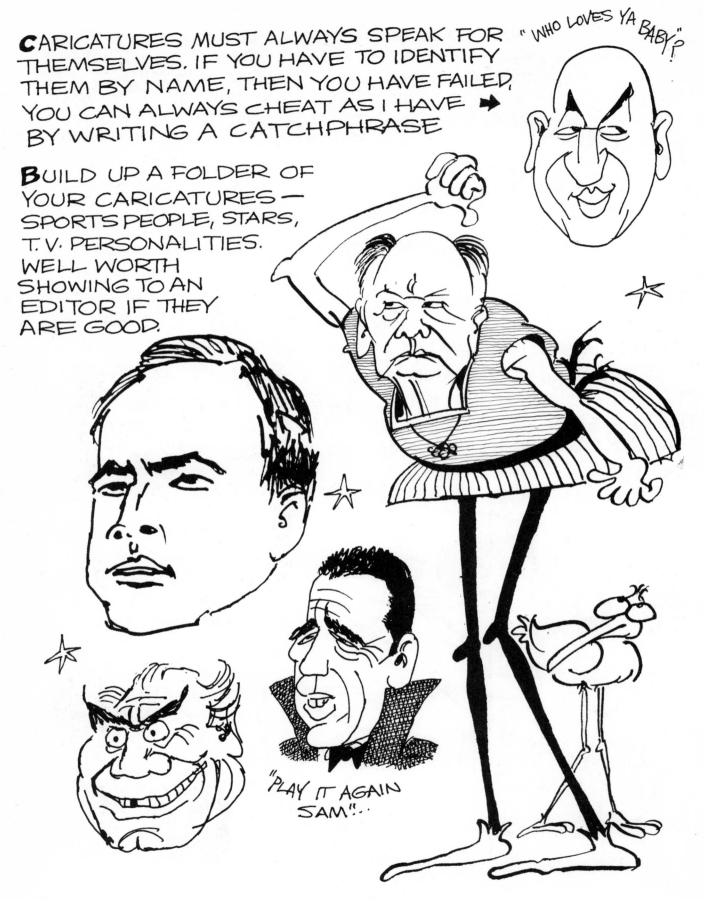

"PLAY IT AGAIN SAM"...

94

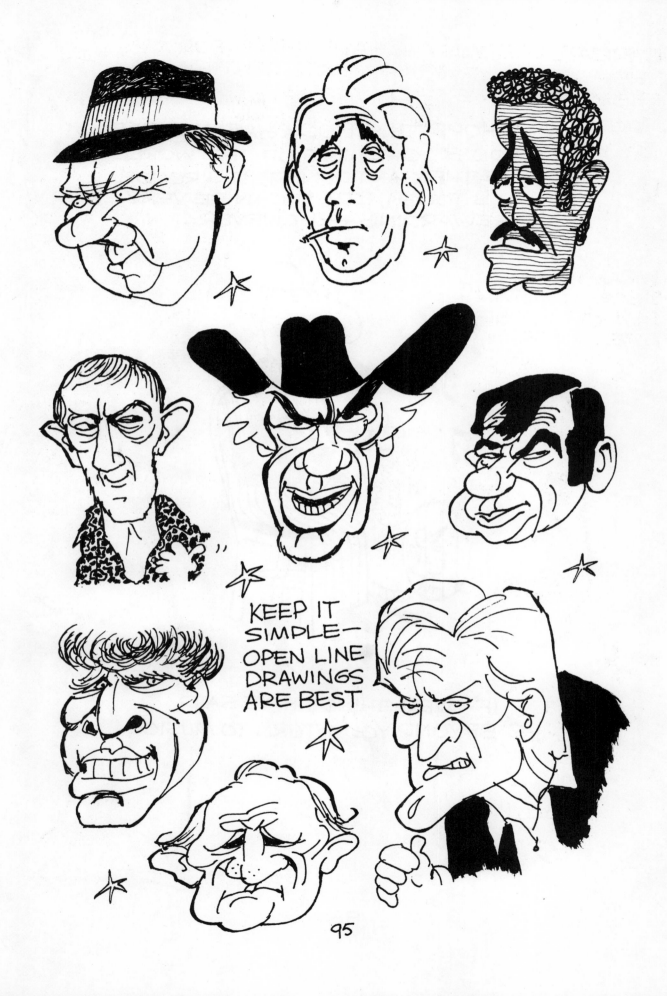

KEEP IT SIMPLE— OPEN LINE DRAWINGS ARE BEST

I HOPE THIS BOOK HAS INSPIRED
YOU BY OPENING UP THE WORLD
OF THE CARTOONIST, IT'S ROUGH,
IT'S TOUGH, BUT IT CAN BE VERY
REWARDING — HOWEVER...

IF EVERYTHING I HAVE SAID
IS BEYOND YOU—TURN TO MUSIC...